The Nikonos Handbook

by Jim and Cathy Church

All text, design, photos and drawings by authors.

Published by Jim and Cathy Church

Copyright © 1986 Jim and Cathy Church

Published by Jim and Cathy Church, P.O. Box 80, Gilroy, CA 95021-0080.

Printed in the United States of America by Herff Jones Inc., P.O. Box 3288, Logan, UT 84321

Library of Congress Catalog Card Number 85-090501

ISBN 0 - 9616093 - 0 - 3

How To Use This Book

Dear Reader,

This is a how-to-do-it handbook for the Nikonos V, and IV-A cameras, and both TTL and manual strobes. Don't try to read this book from cover to cover. Rather, read selectively as described below:

1. Begin by scanning the table of contents. Locate those sections that apply to the equipment you have, and the kind of U/W photography you wish to do.

2. Mark these important sections, in the table of contents, with a colored see-through marker.

3. Then, read only the sections marked—use the marker to highlight the information you need within the sections. Have the equipment nearby that you are reading about so that you can physically go through the steps described. Cover the answers to the "Testing Your Understanding" while you determine the solution. If it involves viewfinder readings, try to aim your camera at a scene that simulates the problem.

4. If you need additional information, use the appendix sections. Again, mark only the information that applies to you.

5. As you decide to buy more equipment, read and mark the additional sections.

We have omitted much of the information already provided in the owner's manuals of the equipment discussed. Rather than subject you to needless duplication, this book takes you beyond the manuals. It gives you step-by-step procedures for using your equipment to its fullest advantage.

We have enjoyed writing this book, and sincerely hope that you will enjoy using it.

Our best wishes,

Jim and Cathy Church

This book has been written and published solely by Jim and Cathy Church. No manufacturer or distributor of photographic equipment has provided financing, or seen or edited the text or illustrations prior to printing.

However, we sincerely thank NIKON, INC., and the other manufacturers whose equipment is included in this book, for their assistance. They provided us with technical information and loaned us the U/W photographic equipment needed to research this book. We are grateful for their excellent support.

TABLE OF CONTENTS

WELCOME TO NIKONOS PHOTOGRAPHY

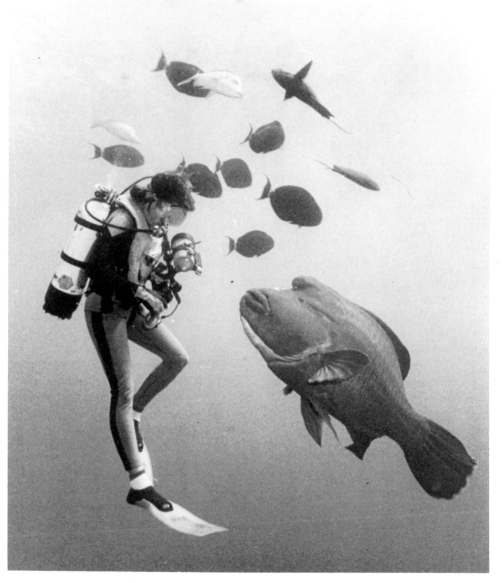

Cathy meets a Napoleon wrasse in the Red Sea. Taken with a Nikonos 15mm lens.

Chapter I

The Nikonos Camera

The Nikonos is an amphibious camera—it can be used either in air or underwater without a special housing. A series of gaskets and O-rings completely seal the camera as well as the accessory lenses and strobes.

THE ADVANTAGES

The Nikonos camera offers many significant advantages when compared to simpler amphibious cameras or to housed 35mm SLR (single lens-reflex) cameras:

• The Nikonos is the lightest, most compact 35mm camera of its quality and versatility. This will be important when you are entering the water from a small, rocking boat, or if you must cross rough terrain to get to the dive site. The Nikonos is easier to use than bulkier housed cameras in adverse conditions such as strong surge, currents, or night dives.

• A wide variety of lenses, from close-up to wide angle, are available from Nikon and other manufacturers, and each lens can be attached to any model Nikonos camera body.

• Many manual and automatic (including TTL) submersible strobes are available.

• If you have repair ability and act quickly, a flooded Nikonos is easier to repair than a flooded 35mm SLR.

• You are spared the extra expense, maintenance and bulk of a separate housing. This can be significant to a casual photographer who wants to do other things on his vacation besides tending to photo equipment.

• In our opinion, the Nikonos is "King of the Mountain" for tiny subjects, such as those photographed with a 1:1 extension tube; and large subjects, such as those photographed with a 15mm lens.

THE DISADVANTAGES

Of course, any camera will have its disadvantages:
- The Nikonos is a viewfinder camera, without reflex or rangefinder focusing. Thus, you must judge camera-to-subject distance by eye at medium and long distances. For close-up work, wands or framers are usually used.
- The lack of SLR viewfinding and focusing can make composition difficult because you never see the subject with the same perspective as the lens. This is especially a problem with close-up work. Wands and framers are primitive systems when compared to SLR capabilities. What serious topside photographer would depend on wands and framers above water?
- The focal plane shutters of the Nikonos I, II and III synchronize with strobes only at shutter speed settings of 1/60 or less. The Nikonos IV-A and V, however, synchronize at 1/90 second.

NIKONOS CAMERA BODIES

The Nikonos V is the only model that is being manufactured and distributed at this writing. However, because many Nikonos IV-A cameras are in use, and are still available on the used market, we will include the use of the IV-A in this text. For information about the earlier models, refer to our earlier text, The Nikonos Book.

THE NIKONOS IV-A CAMERA BODY

Introduced in the U.S. in 1980, the Nikonos IV-A was a radical departure from all earlier Nikonos camera bodies. Based on the Nikon EM (an automatic-only land camera), the Nikonos IV-A had the feel and appearance of a topside SLR (single-lens reflex). The major features were as follows:
- The Nikonos IV-A had a built-in, aperture-preferred automatic exposure control for sunlight exposures. The user set the desired aperture, and the IV-A automatically selected a stepless shutter speed from 1/30 to 1/1000 second. The only shutter speed settings the photographer made were B (bulb), A (automatic), and M90.
- The camera had a one-piece body with a hinged rear camera back that opened for film changes. Thus, the lens no longer had to be removed to change film.
- The film advance lever was the standard ratchet type that wound in one 144 degree movement or several smaller movements of the thumb. The separate shutter release was tripped with the right forefinger.
- The viewfinder was larger and was repositioned at the upper center of the camera body. It was marked for the 35mm lens and contained an LED (light-emitting diode) display for the built-in automatic exposure system

and for the ready light of the Nikonos Speedlight SB-101 (strobe).

• The IV-A shutter speed dial had positions for A, M (mechanical), B (bulb), and R (rewind). The A setting was for sunlight exposures with the built-in automatic exposure control. The M setting locked the shutter at 1/90-second, for synchronization with strobe. There were no other manually-controlled shutter speeds.

• Because the FP (focal-plane flash bulb) contact of the flash socket was used to wire the ready-light LED display of the Nikonos Speedlight SB-101 (strobe), the IV-A couldn't trigger flashbulb units.

When the IV-A was announced, many U/W photographers, dealers and manufacturers were worried about the IV-A's compatibility with existing Nikonos accessories. The previous lenses and flash connectors would fit the new camera body, but the Nikonos Close-up kit required a longer support rod mount, and the existing 15mm lenses couldn't be used with the automatic exposure control. In addition, the different shape of the body rendered many baseplates and brackets obsolete.

In our opinion, the greatest advantages of the Nikonos IV-A over earlier models were:

• The faster 1/90-second strobe synchronization provided sharper images when sunlight exposures were taken with flash fill.

• Film changing was faster.

• The auto feature is valuable in many fast action situations.

• The long auto exposure capability can be used for some special creative effects.

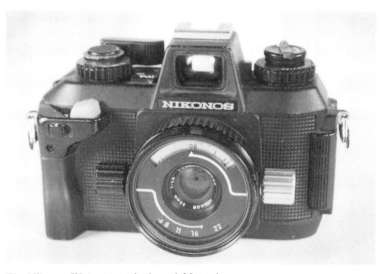

The Nikonos IV-A camera body and 35mm lens.

However, there are several serious drawbacks to the Nikonos IV-A:
• The "anatomical grip" (the shape of the camera body as you hold it in your right hand) was great if you held the camera with two hands. But for one-hand camera operation, it was awkward.
• The automatic exposure control had only limited value because the blinking LED dot just didn't give information efficiently. It was cumbersome to peer at the blinking light in the built-in finder, make adjustments to the camera, follow your subject and try to compose your picture through a second, auxiliary, viewfinder.
• And, serious U/W photographers bemoaned the loss of manually-controlled shutter speeds.

THE NIKONOS V CAMERA BODY

Introduced in the U.S. in 1984, the Nikonos V is definitely the finest Nikonos produced to date. While working with the previous IV-A we made many suggestions to Nikon for improvement. And whether the ideas were ours or theirs, we are pleased to see many of our suggestions become a reality with the V. While this new Nikonos has the same general size, shape and appearance as the Nikonos IV-A, there are several important differences:
• The shutter speed dial has settings for A (auto); M90 (mechanical) which locks the shutter at 1/90 even if the battery fails; manually set quartz-timed settings for 1/30, 1/60, 1/125, 1/250, 1/500, 1/1000 sec. and R (rewind).
• The automatic exposure control (for sunlight exposures) now displays the shutter speed automatically selected by the camera, or it can tell you which shutter speed you should select manually.
• The camera has two internal SPD (silicon photodiode) sensors. One is for the sunlight automatic control, the other is for the TTL (through-the-lens) flash metering with TTL strobes.
• The flash socket now has five pins rather than three. The two additional contacts are for TTL automatic exposure control for strobe exposures. Because the two additional pin contacts can retract, strobe cord connectors for the Nikonos III and IV will also fit the Nikonos V. Of course there is no TTL function with the older strobes anyway, so you simply use the strobe on manual or automatic as you would with a Nikonos III or IV. The flash contacts appear to be sealed against moisture. We've seen a flooded flash socket blown dry with low-pressure air from a scuba tank, and the camera was put back into service immediately.
• The shutter release has been angled, and the grip at the rear of the body has been built up slightly, to improve your ability to grip the camera with the right hand only.
• The camera back release button has been improved so you won't accidentally unlatch the camera back while underwater.

• Other differences include an easier-to-read film counter, improved water-resistant sealing of the internal electronics, and green or orange exterior trim.

• All previous Nikonos lenses will fit the Nikonos V camera body, but some lenses (Nikonos old-style 15mm and Sea & Sea 18mm) can't be used in the automatic mode.

Again, as word of a new Nikonos spread, many persons wondered if past lenses and flash connectors would be compatible. However, lenses, flash connectors, baseplates and most accessories that could be used with the Nikonos IV-A could be used with the Nikonos V. The biggest camera body changes, which obsoleted many accessories, occurred when the IV-A superseded the III.

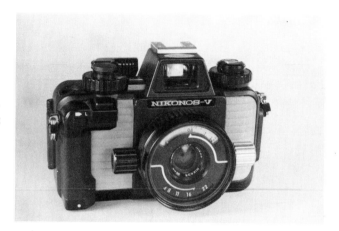

The Nikonos V camera body and 35mm lens.

LENSES FOR THE NIKONOS

At this writing, Nikon offers four lenses for U/W photography with the Nikonos camera: the 35mm, 28mm, 20mm and 15mm lenses, as well as a supplementary close-up lens and a 28mm lens for topside use. Any Nikon lens will attach to any model of the Nikonos camera body. However, the older model 15mm lens can't be used with the built-in metering systems of the Nikonos IV-A and V. For information about non-Nikon lenses, see Appendix D.

NIKKOR LENSES FOR THE NIKONOS CAMERA					
	80mm	35mm	28mm	20mm	15mm
Maximum aperture	f4	f2.5	f3.5	f2.8	f2.8
Minimum aperture	f22	f22	f22	f22	f22
Minimum focus (feet)	3.5	2.75	2.0	1.3	1
U/W picture angle (degrees)	22	46	59	78	94

SHOULD YOU TRADE UP?

If you have a Nikonos IV-A or older model, you are probably wondering if you should trade up to the Nikonos V. If you answer "yes" to any of the following questions, then you should buy the Nikonos V:

1. Do you want to use a TTL strobe?

2. If you presently have a Nikonos III or older model, do you want to have built-in automatic exposure controls for sunlight exposures?

3. If you presently have a Nikonos IV-A, do you want a camera with an automatic exposure control system that (a) shows the shutter speeds automatically selected, and (b) which can be used when the strobe is turned on? Keep in mind that a separate light meter can do this for you more quickly and often more accurately than a built-in system.

4. Do you want a camera that has both stepless automatic shutter speeds from 1/1000 to several seconds, as well as capability to select standard shutter speeds from 1/30 to 1/1000?

If you have an older Nikonos, an accurate exposure meter, a manual strobe that you know how to use, and a good selection of lenses, close-up lenses and extension tubes, and are happy with your results, think twice about changing systems. If you specialize in close-ups, a Nikonos III and a small, manual strobe are hard to beat. For wide angle, a Nikonos IV-A (which synchronizes with strobe at 1/90 second), accessory exposure meter and a wide-beam strobe can produce excellent pictures. But if your equipment is too old, spare parts will only become more scarce with time.

The point is this: Don't get trapped in the upgrade frenzy. Many of the world's finest U/W photos were taken with the older equipment. If choosing between a new camera body or adding a wide-angle or close-up lens to your present system, we'd suggest getting the new lens first. If money doesn't matter, then get both because the newer equipment offers more features.

Chapter II

Preparing Your Camera
For Use

It's difficult to photograph a friendly angelfish when your camera is slowly filling with salt water because of a dirty O-ring. To avoid flooding and other problems, prepare your camera for use well ahead of time—not when you're in a rush to get aboard the dive boat.

Begin by clearing a working area with good lighting, and gathering your tools and supplies. For a working surface, try using paper—such as an 8.5 x 14 inch legal pad. This provides a lint-free surface on which you can place camera parts. As for tools and supplies you will need:
• A set of jeweler's screwdrivers.
• An old toothbrush.
• Silicone grease.
• A pencil with an eraser.
• Lens cleaning fluid (available at camera stores).
• Cotton swabs, cotton balls, lens tissue or a lens chamois.
• A blower brush or other brush for cleaning camera bodies.
• A soft, cotton wiping cloth—a fairly new Tee shirt is great, but dirty O-ring grease leaves permanent stains.
• A plastic credit or certification card.
• A nickel (for unscrewing flash socket plugs and battery compartment lids).

TESTING THE APERTURE CONTROL

Just because the aperture control knob rotates normally, and the depth of field indicators move, doesn't always mean that the lens aperture is actually changing. If you have turned the knob too hard in either direction, the control mechanism inside the lens mount may have disengaged.

To test the aperture control, look through the aperture and rotate the aperture control knob from maximum to minimum aperture (usually f2.5 to f22). You should see the aperture actually opening and closing. If the aperture doesn't change, it is probably stuck at either f22 or wide open.

TESTING THE FOCUS CONTROL

Although the focus control knob rotates, you should verify that the focus control is actually working.

To test the focus control, lay the lens assembly face down on a table top. From an angle, look at the retaining ring around the rear element.You should be able to see the rear lens element move downward about one-eighth inch as you turn the focus control from infinity to minimum distance. And when you turn the focus back from minimum distance, you should see the element move back up again.

If the rear element doesn't move when you turn the focus control, the lens is stuck at either infinity or minimum distance. Note: With the 15mm lens, the movement is quite small so look closely.

Note: The focus control mechanism of the Nikonos 28mm lens may disengage if installed onto, or removed from the camera when the lens is focused for infinity.

CHECKING THE BAYONET MOUNT

Look at the rear of a Nikonos lens and you will see four or six tiny screwheads. These spring-loaded screws allow the rear of the lens (the bayonet mount) to pull away from the lens assembly when the lens is attached to the camera body.

Checking the bayonet mount is easy:
1. Set the focus for minimum (so focus control doesn't disengage) and hold the lens with one hand at its widest part. Grasp the two flanges of the spring-loaded mount with the other hand. You should be able to pull the spring-loaded bayonet mount away from the main lens assembly by about one-eighth inch. Look under the lens mount for moisture or corrosion. As you pull the lens outward, the small movement should be smooth, and the spring tension should pull the rear lens mount back in place when you let go.
• If the movement is rough, and you can see corrosion around the screws and guide pins, seawater has probably seeped into this area.

2. Use a small screwdriver to check the tension of the four or six spring-loaded screws at the rear of the lens mount. If loose, tighten them with a jeweler's screwdriver, but don't use excessive force.
• If the screws are loose, the bayonet mount can pull away from the lens assembly too far. This could cause the focus control to disengage and could allow seawater to seep past the lens O-ring.

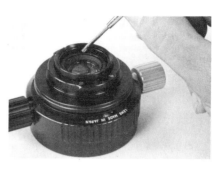

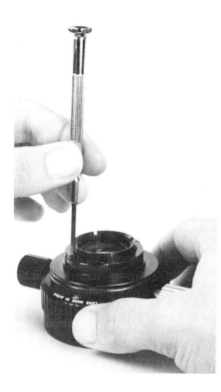

ABOVE: Inner lens mount should move up and down when focus is changed. BELOW: Spring-loaded mount should move freely. LEFT: Check screws for proper tension.

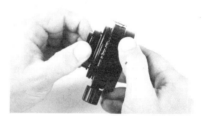

REPAIRING THE LENS

If your lens fails the aperture or focus tests, or the spring-loaded screws are corroded, you should send the lens to a qualified repairperson. If you elect to do the repair yourself, refer to Appendix A.

BASIC LENS CLEANING

Cleaning the glass element at the rear of a Nikonos lens assembly isn't routine maintenance—clean the lens only if it is dirty. Cleaning is easy, but you must be careful not to damage the lens coating:

1. Look for dust particles on the rear glass lens element while holding the lens at an angle. Loose particles can usually be blown off with gentle puffs of air. But if the lens is dirty, clean it with a soft wad of cotton, lens tissue or a Q-tip moistened with lens cleaning fluid.

Don't clean the rear lens element with a brush. The bristles will invariably pick up some silicone grease from the metal lens mount (or camera body, if you used the same brush) and will smear the grease onto the lens.

We use air from a blower brush (with the brush part removed) rather than canned air, mainly because the blower never runs out of air.

GETTING GREASE OFF THE LENS

Suppose your rear lens element looks as if you greased it instead of your O-rings. Regular cleaning techniques won't work, and you dare not rub the surface too much because you could damage the fragile optical coating.

But don't panic—the job is easy. All you need is clean water with a small amount of liquid dish detergent. It works like this:

1. Fill an empty film cannister about two-thirds full and add two drops of dish detergent. Stir or replace the lid and gently shake the cannister to mix the solution.

2. Dip a clean cotton swab into the solution, then press it against the side to remove excess liquid—you want the swab wet, not dripping.

3. Hold the lens so the rear element is angled downward (so any excess fluid won't get past the rear element), and gently clean it with the swab.

4. Use a new, dry swab to remove the fluid.

5. Then, use another swab moistened with plain water (or lens cleaner) to rinse the surface.

6. Dry the surface with a swab, soft cotton or a lens chamois.

If you don't have cotton swabs, soft cotton or a lens chamois, you can substitute soft facial tissue. As for the effects on the lens coating, we've not been able to detect any damage. Use the fluid sparingly, and only touch the surface of the lens lightly when applying fluid or wiping it off.

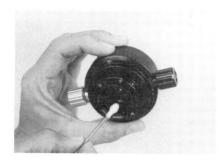

LEFT: A cotton swab, moistened in a mild solution of water and dish detergent, can be used to remove grease. The swab should be damp, not dripping. Use a new dry swab to remove the liquid. Tilt the lens element downward so water can't seep past the lens.

RIGHT: You can finish with standard lens cleaner and lens tissue. Apply a few drops of lens cleaner to a wad of lens tissue. Tilt the rear lens element downward so the cleaner can't seep past the element. This is not preventative maintenance—only clean lenses when cleaning is needed.

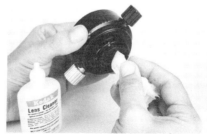

CLEANING THE LENS PORT

If there is grease or oil on the lens port (the window at the front of the lens), wash it off with detergent and water and wipe dry with a clean soft cloth. Don't allow water droplets to dry on the lens as these can create water spots that are hard to remove.

We also clean the ports of Nikonos 28mm, 35mm and 80mm lenses with alcohol, but don't use alcohol on wide-angle dome ports because alcohol may damage plastic ports.

CAMERA CLEANING CHECKLIST

If you complete the following checklist after each photo trip, the camera will be ready for storage and ready for your next trip:
• Wash and soak the exterior of your camera and accessories.
• Clean and lubricate the lens and body main o-rings.
• Clean the o-ring grooves.
• Clean the camera body.
• Clean and lubricate the rewind shaft.
• Clean and lubricate the flash socket.
• Clean and lubricate the battery compartment and lid.
Each of these steps will be explained in the following sections:

WASH AND SOAK THOROUGHLY

That quick dip in the resort rinse tank wasn't good enough. It was probably too quick and the water probably was contaminated with salt.

Loosen all bars and brackets and rinse the camera and accessories with a hose or water tap. Flush out the film speed knob, ISO dial, shutter release and other such places that can trap seawater. Then—especially if the trip is over—soak the camera and accessories in a container of fresh water for at least an hour.

After the soaking, clean and lubricate the camera O-rings. Unscrew all O-ring-sealed fixtures for cleaning and lubrication because these fixtures can trap water. As examples, the battery compartment caps of some strobes (such as the Nikon SB-101 and SB-103) will hold trapped salt water for days!

To prevent salt crystals from forming on hidden O-rings (on the control knobs, rewind shaft, etc.) don't allow the camera to dry completely before being washed in fresh water. In hot, dry climates, wrap your camera equipment in a wet towel to keep it damp until fresh water is available.

Tiny salt crystals can allow a tiny bit of water to seep past an O-ring before the crystal dissolves. The water may not cause a noticeable flood or immediate damage, but start corrosion that causes problems later.

REMOVING THE LENS O-RING

You don't need fancy tools, just your fingers:

1. Wipe the grease from the exposed surface of the O-ring. This allows your fingers to get a better grip.

2. Hold the lens assembly face down with one hand.

3. With the thumb and forefinger of the other hand, squeeze the O-ring from opposite sides—hold your thumb in place and push with your forefinger. This will cause the O-ring to stretch and bulge outward from its groove.

4. Slip a finger underneath the bulge and slide it around. This lifts the O-ring from its groove. Be careful not to touch the glass lens element with a greasy finger or O-ring.

5. The lens O-ring and other removable O-rings can be soaked in a bowl of fresh water to dissolve salt.

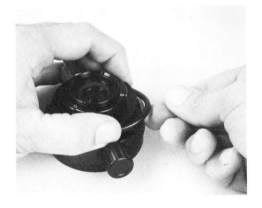

If the O-ring is too slippery to push with your finger, wipe it clean with a cloth, or place the cloth over your fingers to gain traction. Don't use metal tools to remove O-rings. You could damage both the O-ring and its groove. If you must pry, use a toothpick or edge of a credit card.

REMOVING THE IV-A CAMERA BACK O-RING

The Nikonos IV-A camera back is sealed with a gasket rather than a true O-ring. This gasket has ten pairs of small winged-shaped projections that fit into small notches along the edges of the camera back O-ring groove.

To remove the gasket, slip the edge of a credit card into the groove, beside the gasket—off center at the bottom of the door to avoid jamming the card against one of the projections. Gently raise the gasket to form a bulge that you can grasp to pull the gasket out of its groove.

The rounded edge of a certification or credit card can be used to remove the camera back gasket of a IV-A or the camera back O-ring of a Nikonos V.

Later, when replacing this O-ring, check that the winged-shaped projections are seated into their slots. If necessary, use the edge of the credit card to press them in place. Note: The upper, middle section of the camera back groove doesn't have a bottom notch for the gasket projection. Just press the projection in place so it doesn't jam and rotate the gasket.

REMOVING THE V CAMERA BACK O-RING

You can remove the camera back O-ring of the Nikonos V by pressing the rounded corner of a plastic credit or certification card beneath the O-ring and gently lifting it out of its groove (as shown in the owner's manual).

Another method is to press on the O-ring, at the top of the camera back, with two finger or thumb tips. Squeeze the fingers together and the O-ring will bulge outward. Slip a finger underneath this bulge and lift the O-ring out.

Using your fingers to create a bulge is a technique that can be used with a variety of O-rings.

CLEANING THE O-RING GROOVES

Clean the O-ring grooves of the lens assembly and Nikonos V camera back by wiping them free of dirt and grease. You can use the folded edge of your wiping cloth, a lint-free paper towel, or a cotton swab. If you use a cotton swab, flatten the tip with pliers first so it will fit into the grooves. Cotton swabs with plastic sticks flatten much better than swabs with wooden sticks.

Swabs don't work as well with the Nikonos IV-A because they jam and leave lint at the turns in the groove. Use a folded edge of the cloth or paper towel.

After the grooves have been cleaned, moisten your wiping cloth (or towel or swab) with silicone spray. (Use the spray well away from lenses.) Then, give the grooves a final wipe. The silicone will pick up any small bits of lint and will leave a thin coating of silicone in the groove.

CLEANING AND GREASING O-RINGS

Clean O-rings by gently pulling them through a fold of soft cloth. If grease sticks to the O-ring, spray it with silicone spray to soften the grease and wipe it clean.

Lubricate O-rings by applying a thin coating of silicone grease with your fingertips. A lubricated O-ring should appear shiny—without visible globs of grease on its surface.

An O-ring that is kept clean and greased will last for years. We have several Nikonos cameras—with the original O-rings—that are over ten years old.

Apply silicone grease sparingly. Too much grease will hold sand.

CLEANING THE CAMERA BODY

Sweep out the inner camera body with a soft artist's brush. If you have grease on the pressure plate, dampen a soft cloth with water and liquid detergent and wipe the grease off (without dripping water inside the camera).

Look for the surface that the camera back O-ring (or IV-A gasket) presses against when the back is closed. Wipe this surface clean and double check that you haven't left any lint behind. Spray some silicone onto a cotton swab and use the swab to wipe a thin layer of silicone onto this surface.

Use the tip of a small jeweler's screwdriver to apply a tiny drop of lubricant (such as liquid Teflon) to the camera back latch on both the inside and outside of the camera body. Wipe off any excess!

Clean the insert at the front of the camera body (where the lens attaches) with a soft cloth. Then, with a fingertip, give it a thin coating of silicone grease.

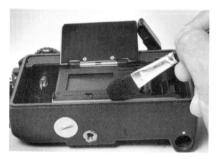
Remove dust from camera body.

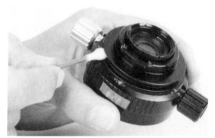
Clean O-ring sealing surfaces.

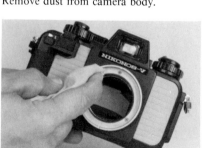
Clean and lubricate lens insert.

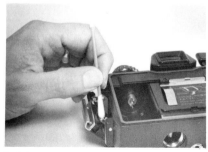
Lubricate camera back latch.

CLEANING THE REWIND SHAFT

Pull the rewind crank out to the rewind position. Press a fold of soft cloth or lint free paper towel against the side of the rewind knob shaft and rotate the knob to wipe off the grease and dirt. Then, place a tiny—repeat, tiny—speck of silicone grease on the tip of a jeweler's screwdriver or toothpick and gently apply this grease to the rewind knob shaft. (Be careful not to scratch the shaft.) Rotate the shaft as you press it down to lubricate the shaft and its hidden O-ring.

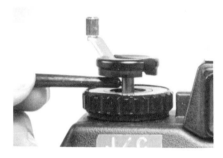
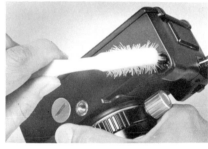
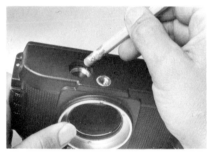

UPPER LEFT: Apply a tiny speck of silicone grease to the rewind shaft. ABOVE: Use a toothbrush to clean debris from threads of flash sockets, plugs and connectors. LOWER LEFT: After cleaning battery compartment lid threads with toothbrush, clean battery contacts with pencil eraser.

CLEANING THE FLASH SOCKET

Our procedure applies to the flash socket and either the flash socket plug or a strobe cord connector:

1. Unscrew the plug or connector.

2. Squeeze the O-ring off the plug or connector with your fingertips.

3. Use a toothbrush to clean the threads of the plug, connector and flash socket.

4. Finish cleaning by wiping the threads and the O-ring with a soft cloth. When wiping the flash socket threads, be careful not to insert the cloth far enough to reach the flash contacts.

5. Put a tiny—repeat, tiny—dab of silicone grease on a finger tip and use this fingertip to rub grease into the flash socket threads. Then, apply a tiny amount of grease to the plug or connector threads, and to the O-ring.

6. Put the O-ring back and screw the plug or connector back into the camera.

CLEANING THE BATTERY COMPARTMENT

Just because the battery in a Nikonos IV-A or V may last a couple years, doesn't mean that you should ignore the battery compartment. Remember that seawater can seep in as far as the O-ring and cause corrosion at the O-ring sealing surface of the camera body:

1. Unscrew the battery compartment lid. A nickel fits the slot and works nicely if the lid isn't in too tight.

2. Pinch the O-ring out with your fingers.

3. Clean the plug and socket with a toothbrush and soft cloth.

4. Clean the contact surfaces inside the plug and socket with a pencil eraser.

5. Wipe the battery with a soft cloth.

6. Apply a thin coating of silicone grease to the O-ring and the threads of the socket and plug.

7. Replace the O-ring.

8. Replace the plug—make sure the plus side of the battery (where the writing is) faces up, and screw the plug in finger tight.

• Warning: press in on the plug and be sure that it is square to the camera body as you screw it in. The plug is easy to cross-thread.

CLEANING OTHER EQUIPMENT

Now that we've taken you through camera cleaning and lubrication, step by step, you should be able to anticipate how to clean and lubricate other equipment as well. The basics are the same:

• Clean the O-rings of extension tubes the same way you clean lens O-rings, and clean the front sealing surface of an extension tube the same way you clean the insert at the front of a camera body.

• O-rings that seal many strobes can be cleaned the same way as you cleaned camera O-rings.

• Strobe charge port plugs, and detachable strobe cord or sensor plugs can be cleaned with the same basic techniques you used with flash sockets and battery compartments.

• With the Nikonos Close-up Outfit, loosen the tightening screw at the side of the mount. Apply a tiny drop of WD-40 or Teflon lubricant to the threads and turn the screw to work the lubricant into the threads. (When using spray lubricants, spray them onto a pointed tool well away from the lens. The spray will run down the tool and the drop formed can be placed right where it is needed. The lubricant sprays can easily damage the coated surfaces of the Close-up kit.)

Take care not to allow grease or spray lubricants to come in contact with optical glass surfaces. If so, clean off any grease immediately, as discussed on page 10.

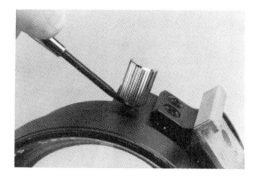

The tightening knob on the side of the Nikon Close-up Outfit can corrode and freeze in place quickly. After use, work the knob under a running water tap. Apply a small drop of Teflon or silicone spray as preventative maintenance. If corroded in place, apply drops of WD-40 and allow it to soak in before attempting to loosen the knob.

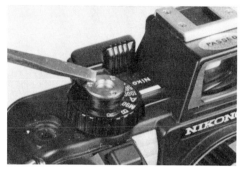

At this writing, the film advance lever is covered with a rubber cap that soon falls off. We leave the cap off as it could trap water and cause corrosion where the three pins hold the lever in place. On one of our cameras, the lever corroded and broke off.

The SB-101 and SB-103 battery compartment lids can trap water for days. Hold the lid downward when removing it to prevent trapped water from running inside of the battery compartment.

Loosen all threaded parts of the arm and bracket system and lubricate the threads with Teflon or silicone spray. Use WD-40 to remove corrosion. At this writing, the strobe arm traps water inside the handle. Swing the handle so centrifugal force forces trapped water out through the small drain holes.

LOADING THE CAMERA

Please don't skip this section because you, "already know how to load a Nikonos IV-A or V." Our method is faster and easier than the method shown in the owner's manual.

Here are the basic steps:

1. Set the shutter speed dial to R (rewind).
2. Rewind the film.
3. With the lens facing upward, open the camera back so that the back swings downward. Drops of water up to the O-ring will now fall downward rather than be sucked into the camera. Wipe off any water droplets on the O-ring and sealing surface.
4. Use your left thumb to lift and free the cassette.
5. Gently tuck the upper right corner of the pressure plate beneath the film advance lever. (If the lever doesn't lift high enough, set the camera for a setting other than R, trigger the shutter, advance the lever once, and return the shutter speed dial to R.)
6. Insert the new cassette—angle in at 45 degrees to get it positioned correctly.
7. Insert the film leader, to about the third hole, into the take-up spool, and turn the base of the spool counter clockwise until the film turns completely around the spool.
• Because the small slot in the film take-up spool is hard to see in dim light, you can paint the edge of one slot and one tooth with white paint.
8. Lower the pressure plate and gently tap the bottom in place.
9. Hold the bottom of the take-up spool with your right thumb or forefinger as you take up the slack in the film cassette by rewinding with the rewind crank.
10. Close the camera back (with IV-A, be sure to close O/C latch).
11. Set the shutter speed dial for a film speed, and advance and trigger the shutter three times (until number 1 shows on the frame counter) to activate the automatic exposure control.

A dab of typewriter correction fluid on the film take-up spools makes it easier to see that you have threaded the film into the slot.

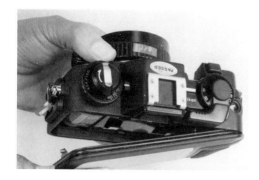

If the camera is damp, tilt it back when opening the camera back lid. Wipe off any droplets of water adhering to the O-ring or camera body sealing surface.

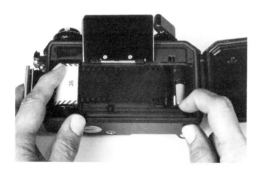

Tuck the film pressure plate beneath the film advance lever so it doesn't get in the way when you load film.

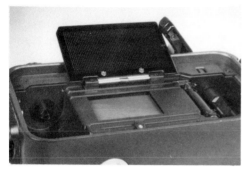

Use a finger or thumb to advance film onto the take-up spool. Note: The shutter speed must be set to R (rewind) postion so the film advance sprocket teeth can move.

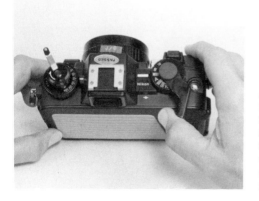

Advance and trigger the shutter three times to get to the no. 1 position on the film frame counter. The rewind crank should turn each time the film is advanced if you have taken up the slack correctly. Rotate the rewind crank against arrow to reset it in down position.

IS THERE FILM IN THE CAMERA?

As much as we try to keep track of such a simple thing as loading film into the camera, the question invariably arises. Usually Cathy wants to know if Jim really put film in her camera this time, or is she just supposed to pose. To find out: Set the shutter speed to any setting other than R (rewind). Raise the rewind crank and gently turn it in the rewind direction. If you feel resistance, stop. There is film in the camera.

IS THE FILM ADVANCING?

Just because the film is over the sprockets, and it passes the test for "Is there film in the camera?" you still can't be sure that it was loaded correctly and that the film is advancing. To be sure, set the camera for any shutter speed other than R (rewind) and gently turn it in the rewind direction. Stop when you feel resistance. Trigger the shutter (if necessary), and watch the rewind crank as you advance the film for the next exposure. The rewind crank will revolve if the film is advancing.

IS THE FILM REWOUND?

How often have you opened the camera only to see that horrible sight of film extending out of the cassette and wrapped thickly around the take-up spool? If you can close it faster than the speed of light, your film will be safe. But don't walk around with it open, sobbing into your camera. Close it immediately (time makes a difference) and you may lose only the outer few frames of film. Short of taking a quick peek, how can you be certain that the film is rewound before opening the camera?

Simply turn the shutter speed control from R (rewind) to any shutter speed, including B (bulb). Be sure that the rewind crank is in the up (rewind) position, and gently try to continue rewinding. If you feel resistance, the film hasn't been completely rewound. If you don't feel any resistance, the film has been rewound. You should do this check routinely until you get the feel of the rewind characteristics of your camera. Some rewind cranks slip slightly and aren't rewinding when you think they are.

Chapter III

How To Take
Sunlight Exposures

You can take many kinds of pleasing U/W pictures—such as upward silhouettes, kelp scenics and moody wreck interiors and exteriors—with sunlight alone. You don't need a strobe to get started in U/W photography.

Upward camera angles that silhouette divers or marine life and separate them from their backgrounds are often best. But downward camera angles can also be effective if you are photographing dark subjects against light backgrounds or light subjects against dark backgrounds. Look for forms, shapes and contrast. Don't photograph subjects that depend on bright colors for impact. A good natural light picture is one that looks better without strobe light.

STANDARDIZE YOUR PROCEDURES

Create simple, effective habit patterns that eliminate unnecessary decision making. This isn't required, but starting at the same place is like starting on home row of a typewriter keyboard. For example, we suggest putting the 35mm and 28mm lenses on so the aperture control knob is always on your left side as you hold the camera for picture taking. *If you preset for f22, and then turn the knob away from you as you adjust the aperture, you will always see the viewfinder displays in the same sequence.*

NIKONOS AUTO EXPOSURE CONTROLS

With either the IV-A or V, the automatic exposure control (when the film speed dial is set for A) is aperture preferred—you set the aperture you prefer, and the auto control sets the shutter speed. The shutter speeds selected are stepless and can be anywhere on or between the standard shutter speeds. As examples, the auto could select 1/37 second rather than 1/30, or 1/115 second rather than 1/100.

DON'T WORRY, THE AUTO IS O.K.

Two events may fool you into thinking that the automatic control of a IV-A or V isn't working:

1. After the camera back has been opened, the metering system doesn't turn on (so you won't see any display in the viewfinder) until the film advance lever has been worked three times to move the film counter to the #1 position. This happens whether or not there is film in the camera.

2. If the camera only sees darkness when the shutter is triggered (if the lens cap is on, or the lens is face down on a table top), the camera may appear to be broken: The film advance lever won't move, and the shutter won't trigger. This is because the shutter is still open for a long exposure of several seconds. Turning the film speed dial to a setting other than A will free the shutter if you don't want to wait for it to close. You can do this underwater if you need to.

USING THE NIKONOS IV-A AUTO

The Nikonos IV-A auto system has only a single LED (light-emitting diode) in the viewfinder. If this light is glowing, it is telling you that the camera has selected a shutter speed somewhere between 1/30 and 1/1000 second. If the light is blinking, it is telling you that the shutter speed is faster than 1/000 second (in bright conditions), or slower than 1/30 second (in dim conditions).

You should adjust the aperture until you get the glowing light. A shutter speed faster than 1/1000 second may not be accurate, and it is difficult to hold the camera steady enough for a speed slower than 1/30 second. You can, however, mount the camera on a tripod for special effects requiring long shutter speeds. Generally, you will want a speed of 1/60 or 1/125 second.

Here's how to use the IV-A automatic control:
1. Set the film speed dial for the ISO film speed you are using.
2. Attach the lens (other than the 20mm) so the aperture control knob is to your left as you hold the camera for picture taking, and preset the aperture for f22.
3. Advance to frame #1 to turn on the auto.
4. Compose the picture in your viewfinder.
5. Depress the shutter release halfway. Assuming that the f22 starting point doesn't admit enough light for an exposure, the red LED will be blinking.
6. With your left hand, open the aperture by turning the aperture control knob away from you until the LED reaches the "quiver point" between blinking and glowing. At this aperture, the shutter speed is about 1/30 second.

7. For 1/60 second, open the aperture by one more stop (the next lower-numbered f-stop on the scale).

8. If you need 1/125 second to stop action, open the aperture one additional f-stop.

9. Set the focus and look at the depth of field scale to verify that the desired subject area will be sharp.

10. Take the picture.

TESTING YOUR UNDERSTANDING

PROBLEM: Your Nikonos IV-A is loaded with ISO 100 film, and your 28mm lens is preset for f22. Suddenly, you see a manta ray. He is swimming along the wall about eight feet below the surface. You look into the viewfinder and see that the LED is blinking. What should you do?

SOLUTION: Aim the camera at the openwater background where you anticipate the manta ray will be. Open the aperture until you reach the quiver point, then open at least two more stops to get a high enough shutter speed (1/125 second) for a sharp picture. Check the focus, pan with the moving manta ray and take the picture.

NIKONOS IV-A METERING PATTERN

The Nikonos IV-A metering system is center weighted. It responds more to the light in the center of the picture area than to the light near the edges of the picture area. Thus, the system exposes for the subjects in the central picture area.

HOW TO TEST THE IV-A METER

If you have been getting erratic exposures, or if your camera is new and untried, it is a good practice to test the accuracy of the metering system. The test is easy. All you need is an unobscured midday sun (above water) for the *f16 test.*

The f16 test means that with a subject of average reflectance frontlighted with bright sunlight, the correct exposure should be f16 at the shutter speed closest to the ISO film speed. For ISO 64 film, the correct exposure for an average outdoor scene in bright sunlight would be f16 at 1/60 second.

Here's how to do the f16 test with a Nikonos IV-A:
1. Set the film speed dial for ISO 64, the shutter speed dial for A (automatic) and the focus for infinity.
2. With the sun behind you, aim the camera at an average topside scene such as an average gray fence, perhaps with some foliage at the bottom and some sky at the top.
3. Adjust the aperture until you reach the "quiver point" between a glowing and blinking LED display. The quiver point indicates a shutter speed of approximately 1/30 second. Open the lens one more stop to get a shutter speed of approximately 1/60 second.
4. Look at the aperture scale. The aperture should be close to f16.

A typical scene for the f16 test. The meter sees some sky, neutral gray fence and green shrubbery. Our Nikonos IV-A, V and Nikon F3 all read f16!

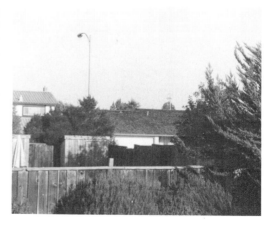

NOTE: If you can't find a typical scene as shown, meter off the open, unshaded palm of your hand. Hold your hand about four or five inches from the lens, so the sun strikes it directly. But because your palm reflects more light than an average scene, the meter will read f22.

If the meter reads too high or too low, adjust the ISO dial until you get the correct reading. Note how many marks on the dial were required for the correction. Use the same number of marks with other ISO film speeds as well. Note: The consecutive marks on the ISO dial are at one-third stop intervals.

USING THE NIKONOS V AUTO

When you use your Nikonos V for the first time, try using it without a strobe. The best place to start is in the controlled environment of a swimming pool. Try photographing a diver with upward, level and downward camera angles. Don't worry about composition—just learn to use the LED exposure displays in the viewfinder.

When using the Nikonos V for automatic sunlight exposures, you first set the aperture, and the system selects the proper shutter speed for an average exposure. The viewfinder display shows the approximate shutter speed that the camera is using or a red (arrow-head) LED underexposure warning.

Here are the steps for using the A (auto) mode:
1. Set the film speed dial for the ISO film speed.
2. Attach the lens (except the 20mm) so the aperture control knob is to your left as you hold the camera with your right hand. Preset for f22.
3. Advance to frame #1 to turn on the auto.
4. Compose the picture in the viewfinder.
5. Depress the shutter release halfway. Assuming that the f22 starting point doesn't admit enough light for an exposure, you will see the red arrow blinking in the lower right corner of the viewfinder. This tells you that you should open the aperture if you want a shutter speed of 1/30 or faster.
6. Turn the aperture control knob away from you until you see the shutter speed you want displayed in the viewfinder.
7. Check your focus and depth of field scale to verify that your important subject areas will be in focus.
8. Take the picture.

To summarize the viewfinder displays:
• When you see *30* in the viewfinder, the camera has automatically set the shutter speed close to 1/30 second.
• If you see two numbers, such as *60 30*, the camera has automatically set the shutter speed close to the halfway point between them.
• Turn the control knob until you see the shutter speed you want. For most of your pictures, use a speed from 1/60 to 1/125.

TESTING YOUR UNDERSTANDING

PROBLEM: You wish to photograph a distant diver slowly descending toward nearby wreckage. You are using a Nikonos V loaded with ISO 100 film and set for A (auto), and a 15mm lens preset for f22. The red arrow is blinking in your viewfinder display. What should you do?

SOLUTION: Open the aperture until the 60 glows. Check the depth of field scale to see if both the wreck and the diver are still sharp. If so, take the picture. If you have plenty of depth of field to spare, open until the 125 and the 60 glow, indicating a speed of approximately 1/90 second. The higher shutter speed helps you get a sharper picture.

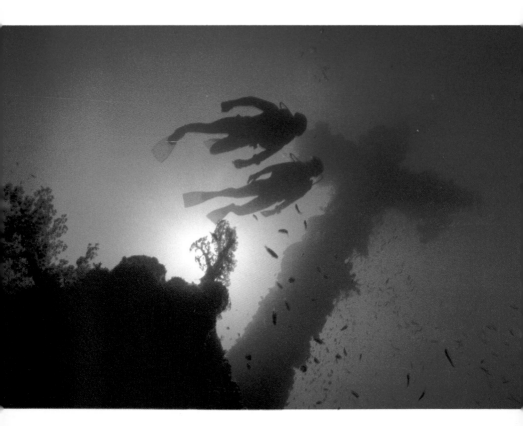

ABOVE: A diver explores Blue Hole in Grand Bahama. Nikonos V set for A (auto), 1/125 second and ISO 200 (with Professional Ektachrome 100) to keep the interior dark.

LOWER LEFT: Two divers descend to the *Fujikawa Maru*, Truk Lagoon. Nikonos V set for A (auto), 1/125 second and ISO100, Professional Ektachrome 100 film.

BELOW: Cathy explores the anchor chains of the sunken *Oro Verde*, Grand Cayman, BWI. Nikonos III, at f4 and 1/60 second, on Professional Ektachrome 64.

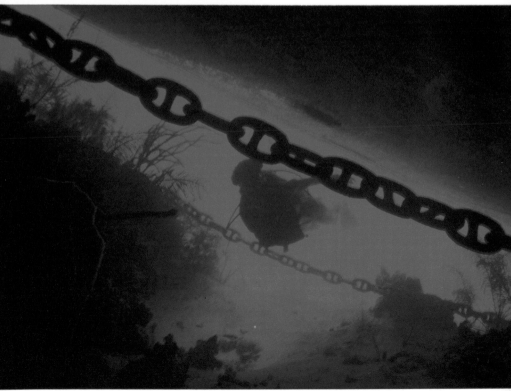

HOW TO TEST THE V AUTO CONTROL

Testing the accuracy of the Nikonos V automatic exposure control is easy. All you need is an unobscured midday sun for the *f16 test*. The f16 test means that with a subject of average reflectance frontlighted with bright sunlight, the correct exposure should be f16 at the shutter speed that is closest to the ISO film speed.

Here's how to do the f16 test:
1. Set the film speed dial for ISO 64, the shutter speed dial for A, the focus for infinity and the aperture for f16.
2. With the sun behind you, aim the camera at an average scene with some foliage at the bottom and some sky at the top.
3. Look at the viewfinder display. For an average scene, it should show the *60* (1/60 second) display.
4. If it shows the *125* or *30*, tilt the camera upward slightly toward the sky, then slightly down toward the ground. If the display varies from *125* to *30*, the average is 60. (Also, see photos and captions on bottom of page 25.)

If the display is consistently too high or too low, adjust the film speed dial setting until you get the desired display. This change in film speed compensates for any meter error.

USING THE V MANUAL CONTROL

Manual control is actually much easier than many people think. Although you are using the built-in metering system, you manually set both shutter speed and aperture, and can easily increase or decrease exposure. We often prefer the V manual control when we wish to control the exposure for specific small highlight areas, or we wish to purposefully add or reduce exposure.

The shutter speed you select glows in the viewfinder. If the camera *thinks* that you should be using a different shutter speed, the shutter speed that the camera would choose blinks in the viewfinder. *You simply adjust the aperture until only one shutter speed—the speed you have chosen—glows in the viewfinder display.*

Here's how to use the manual control:
1. Set the film speed dial for the ISO film speed.
2. Attach the lens (except the 20mm) so the aperture control knob is at your left as you hold the camera with your right hand, and preset the aperture for f22.
3. Advance the film counter to frame #1 to turn on the auto.

4. Set the shutter speed for the speed you want. Assume 1/60 second for this example.

5. Compose the picture in the viewfinder.

6. Depress the shutter release button halfway and look into the viewfinder. You will see the number *60* glowing in the display. The *60* tells you that you have manually selected a shutter speed of 1/60 second. You will also see the underexposure arrowhead blinking in the lower right if the f22 doesn't admit enough light for an exposure.

7. Turn the aperture control knob away from you until the arrowhead disappears, and only the *60* remains in the viewfinder display.

8. Check your focus and depth of field scale to verify that your important subject areas will be in focus.

9. Take the picture.

As you slowly turned the aperture control knob away from you to open the aperture (in step 7) a blinking *30* appeared next to the *60*. The 30 tells you that although you manually set the shutter speed for 1/60 second, the auto system thinks that you should really be using 1/30 second for the aperture you selected. If you take the picture, the auto system is telling you that you will be underexposed by one stop.

If you open the aperture until you have a blinking *125* in addition to the glowing *60*, the auto system thinks that you should be using 1/125 second. The system is telling you that you will overexpose by one stop.

TESTING YOUR UNDERSTANDING

PROBLEM: You are on a drift dive photographing divers swimming along a wall. You have a Nikonos V loaded with ISO 200 film, and are using a 15mm lens set for f11. Because you want a fast shutter speed to stop action, you set the shutter speed dial for 1/125 second. The viewfinder display shows a glowing 125 *and a blinking* 30. *What should you do?*

SOLUTION: Open the aperture until only the glowing 125 *is displayed. Check that you still have enough depth of field and take the picture.*

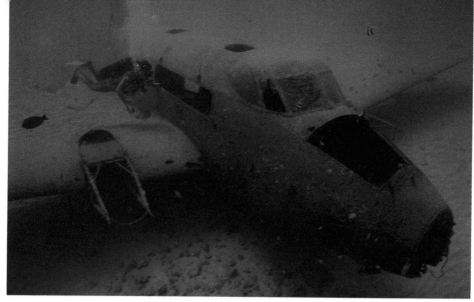

Airplane wreck off Oahu, Hawaii. Nikonos V set for A (auto), 1/125 second and ISO 100 for Professional Ektachrome 100 film.

THE NIKONOS V METERING PATTERN

The built-in metering system of the Nikonos V (for sunlight exposures) is lower-center and bottom weighted: It responds more to the lower-middle and bottom of the picture area than to the top and corners. Therefore, with a level camera angle, it is influenced more by the bottom than the brighter surface above.

For example, if the bottom is darker than the midwater background and surface above, the automatic system tends to open the aperture to lighten the darker bottom. This could cause overexposure in the upper part of the picture.

Here's how to compensate for the metering pattern when using manual shutter speeds:

• Aim the camera so that an area of average brightness—not the brightest or darkest part of the scene—is in the lower center portion of the viewfinder. Set the aperture, then re-aim the camera without resetting the aperture.

• When taking verticals, tilt the camera to the left or right, depending on which side of the picture you wish the meter to respond most to.

Note: If the camera is set for A (auto), the shutter speed automatically changes each time you change aperture and camera angle. You could compensate for the metering pattern by changing the film speed setting, but it is usually easier to use the manual shutter speeds as described above.

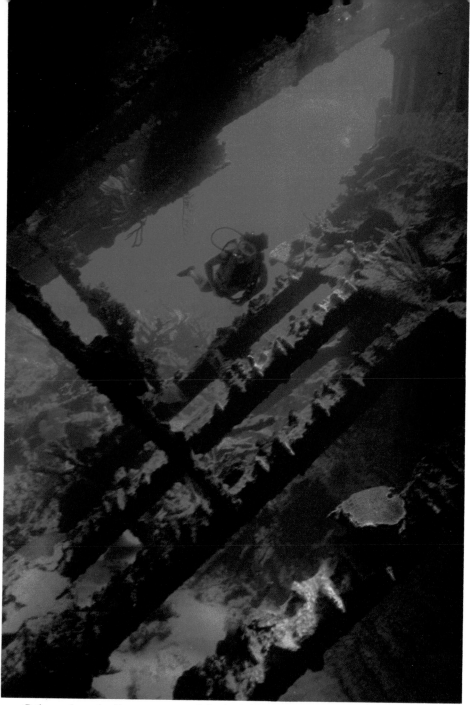

Cathy explores the *Paramatta*, a wreck in the British Virgin Islands. Nikonos V set for A (auto) and 125 second. Jim set the film speed dial for ISO 100 (with Professional Ektachrome 100 film) to maintain exposure in the shadow areas.

BRACKETING AUTO EXPOSURES (IV-A or V)

Bracketing means taking two or more pictures of the same subject—with different exposure settings—to insure that one of the pictures will be exposed correctly. If, for example, you think the correct exposure is f16, but aren't sure, make exposures at f11, f16 and f22. One of these should be close to the correct exposure.

When do you bracket?
• To keep a bright scene bright, bracket to more exposure than the meter indicates.
• To keep a dark scene dark, bracket to less exposure than the meter indicates.
• If confused, and the scene has both bright and dark areas, bracket for both more and less exposure than the meter indicates.

To bracket A (auto) with the IV-A or V, change the ISO film speed setting:
• To increase exposure, set for a lower film speed than you are actually using.
• To decrease exposure, set for a higher film speed than you are actually using.

Note: Simply changing the f-stop doesn't work because the metering system keeps changing the shutter speed to match. You must bracket with the film speed dial.

TESTING YOUR UNDERSTANDING

PROBLEM: You are using a Nikonos (IV-A or V), ISO 200 film and a 15mm lens, to photograph the bow section of a sunken wreck. The dark underside of the bow dominates the lower half of the picture. You want to keep this area dark, and don't want to accidentally overexpose the upper portion of the picture. You try to remember metering patterns, but get confused. What should you do?

SOLUTION: Take three pictures with bracketed exposures. Set the film speed dial for ISO 100, 200 and 400. One of these exposures should be acceptable.

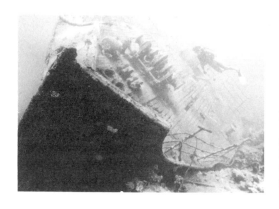

Nikonos V set for ISO 125 for ISO 100 film, to prevent the influence of the dark shadow area under the bow to cause the Nikonos V metering system to overexpose the average area of the deck.

BRACKETING WITH THE MANUAL CONTROLS

With the Nikonos V and manual exposure control with the built-in metering system, you can bracket by changing the aperture. Look in the viewfinder and adjust the aperture until only the shutter speed you selected is displayed. This gives you a basic f-stop around which you bracket.

To bracket for more exposure: Open the aperture until you see both the glowing display for the shutter speed you selected, and a blinking display for a *faster* shutter speed.

To bracket for less exposure: Close the aperture until you see both the glowing display for the shutter speed you selected, and a blinking display for a *slower* shutter speed.

To summarize: If you manually set the shutter speed for 1/60 second, and wish to take three exposures bracketed at one-stop increments:
• Take one picture with a blinking *125* and a glowing *60*.
• Take one picture with only a glowing *60*.
• Take one picture with a glowing *60* and a blinking *30*.

Bracketing with two exposures—normal to more or normal to less exposures—takes practice because the viewfinder displays seem to indicate the opposite of what you want to do. (Remember: A blinking fast shutter speed means that more light is reaching the film than the camera thinks is correct. When you see the blinking light, showing the fast speed, it may be hard to remember that this means more light rather than less.)

Don't be intimidated by the auto system. The tendency is to hesitate if the viewfinder display is signaling, "Hey, dummy, you're doing something wrong." It takes time to get the confidence to talk back to the camera and tell it that you know better!

USING A SEPARATE EXPOSURE METER

If you will be taking a lot of U/W pictures, seriously consider purchasing a separate exposure meter, such as the Sekonic Marine Meter II. You can mount this meter in an Oceanic meter mount and attach it to either the tripod socket on the bottom of the camera, or to a tapped hole in a strobe mounting bracket. Reading the Sekonic Marine Meter II is easier than reading the viewfinder displays of the IV-A or V because:

• You can read the meter as quickly as you can read the speedometer of a car—an arrow points to the f-stop on the meter's scale.

• You can hold the camera and meter about a foot in front of your face and scan the entire scene—from highlight to shadow areas—and can average these readings as you wish.

• You can meter the exact picture area you wish to exposure for.

USING FILTERS

Let's begin by saying that filters don't replace strobe lights as a means of capturing U/W color, and good natural light photos don't depend on color. However, a filter can enhance the colors you see in your sunlight exposures if you need color and don't have a strobe. The best filter we've seen so far is the UR-PRO filter. We've tried this filter with both color print and color slide film, and saw a definite improvement in color. The filter does hold back some light, so you need to open the lens about one additional f-stop. With an automatic Nikonos, the built-in exposure meter automatically takes care of the correction. But if you are using a separate, hand-held exposure meter, take your meter reading through the filter.

WITHOUT FILTER: Sunlight exposure in 20 feet of water. Nikonos V set for A (auto), 1/125 second and ISO 64 for Professional Ektachrome 64.

WITH UR-PRO FILTER: Sunlight exposure in 20 feet of water. Nikonos V set for A (auto), 125 second and ISO 64 for Professional Ektachrome 64.

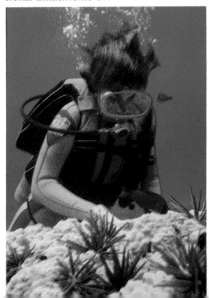

Beneath the kelp forest of Monterey Bay, California. Nikonos III set for Sekonic
Marine Meter exposure meter reading from midwater background just above the sun.
Professional Ektachrome 64.

Chapter IV

How To Use Manual Strobes

A manual strobe has no automatic exposure controls. You use a table of f-stops and strobe-to-subject distances to make your exposure decision. A manual strobe may be *dedicated* or *non-dedicated*. A dedicated strobe communicates with the camera electronically:

With a Nikonos IV-A set for A (auto), the dedicated strobe signals the camera to lock the shutter speed at 1/90 second when the strobe is turned on, and a ready light (lightning bolt) glows in the camera viewfinder when the strobe is recycled.

With a Nikonos V set for A (auto), the dedicated strobe signals the camera to lock the shutter speed at 1/90 second when the strobe is turned on, and a ready light (lightning bolt) glows in the camera viewfinder when the strobe is recycled. The shutter speed is also locked at 1/90 second if it has been manually set for 125 second or higher.

MANUFACTURER'S EXPOSURE GUIDES

Guide numbers are sometimes used to express exposure information. You divide the guide number by distance to find aperture. For example with an U/W guide number of 24 and a distance of three apparent feet, the aperture would be f8 ($24/3 = 8$). Note: In the Nikon SB-102 and SB-103 manuals (at this writing), all the guide numbers are for meters. To convert these to guide numbers for feet, multiply the guide number in meters by 3.3.

TESTING YOUR UNDERSTANDING

PROBLEM: Your SB-103 guide number chart shows a M1/4 (manual exposure control, 1/4 power) guide number of 10 (for meters) for ISO 400 film. What is the guide number for apparent feet?

SOLUTION: It is 33. Multiply the guide number for meters (10) by 3.3 to convert it to a guide number for feet. Thus, 10 x 3.3 = 33.

PROBLEM: Given an U/W guide number of 33 (in the above example), what would the aperture be for an exposure taken with a strobe-to-subject distance of three apparent feet?

SOLUTION: The estimated aperture would be f11 (the guide number of 33 divided by 3 equals 11).

Exposure tables—sometimes in the form of decals that you can attach to your strobe—are popular guides. These are often included in the strobe manufacturer's instructions. They show various combinations of aperture and strobe distances.

Moveable calculators are often hard to use underwater because they can contain too much information and can be confusing. The numbers may be too small for old eyes to read, or the calculator can slip out of adjustment. Use the calculator to determine your basic f-stops, and then make your own exposure table. The easiest approach is to attach your own manual exposure table to the side of the strobe. All you need is white plastic tape, scissors and a laundry marker. Use big letters and numbers so you can see your exposures at a glance. Limit the table to the numbers for the film you are presently using.

Warning: Be wary of manufacturer's exposure guides because some may be based on exposures for light skin tones in clear water. These will underexpose darker subjects in dirtier water. Therefore, before shooting a lot of film on an expensive trip without film processing, be sure to take some test pictures to verify that the exposure table is valid.

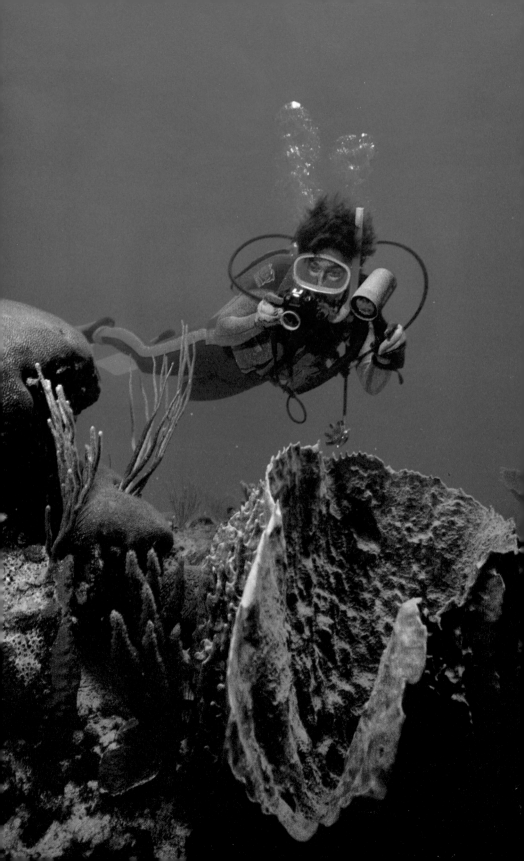

FACING PAGE: Cathy photographing the terrain of Cane Bay Wall, St. Croix, U.S. Virgin Islands. She is using a Nikonos IV-A and Ikelite MS Strobe with the Ikelite #4077 handle. Taken on Professional Ektachrome 64 with a Nikonos IV-A set for M90 and f5.6, with fill lighting from a Subsea Mark 100 Strobe.

SB-102 & 103 EXPOSURE GUIDES

Because Nikon puts a lot of information into the SB-101 and SB-102 calculators, and SB-103 exposure table, using these guides can sometimes be confusing. You can use the calculator or table and completely understand it, but five minutes later you can be completely lost. It isn't just you, we've had these problems too.

If you double check our manual exposure tables (below) against the Nikon SB-102 calculator dial and SB-103 exposure table, you will see that each of our f-stops is one stop lower (lower-numbered) than Nikon's. This is because Nikon's f-stops and U/W guide numbers appear to be for measured rather than apparent distances. Our f-stops are based on apparent distances. We divided Nikon's topside guide numbers by a water factor of three; Nikon divides by two. You may find that a different water factor, such as 2.5 is best for you.

OUR NIKON EXPOSURE TABLES

The following are our versions of manual exposure control tables for the Nikon SB-102 and SB-103 strobes:
 • The first column shows strobe-to-subject distances in the apparent feet you see underwater.
 • The second column shows our suggested f-stops for manual exposure control at full power. Use the f-stops shown in brackets if you use the optional wide-flash adaptor.
 • The third and fourth columns show the f-stops for manual exposure control at 1/4 power, and 1/16 power, respectively.

ESTIMATED MANUAL EXPOSURE TABLE, NIKON SB-102 ISO = 50 or 64			
Distance	Full power	1/4 Power	1/16 Power
1 foot	f22 (16)	f11 (8)	f5.6 (4)
2 feet	f11 (8)	f5.6 (4)	f2.8 (2)
3 feet	f8 (5.6)	f4 (2.8)	f2 (1.4)
4 feet	f5.6 (4)	f2.8 (2)	-- --
6 feet	f4 (2.8)	f2 (1.4)	-- --

ESTIMATED MANUAL EXPOSURE TABLE, NIKON SB-103 ISO = 100			
Distance	M Full	1/4 Power	1/16 Power
1 foot	f22 (16)	f11 (8)	f5.6 (4)
2 feet	f11 (8)	f5.6 (4)	f2.8 (2)
3 feet	f8 (5.6)	f4 (2.8)	f2 (1.4)
4 feet	f5.6 (4)	f2.8 (2)	-- --
6 feet	f4 (2.8)	f2 (1.4)	-- --

TESTING YOUR UNDERSTANDING

PROBLEM: You are on a night dive, and are using a Nikon SB-103, ISO 100 film, and the above exposure table for manual exposure control. You preset your Nikonos 28mm lens for two apparent feet, preset your SB-103 for M FULL (manual exposure control, full power), and have attached the wide-flash adaptor. The strobe will be bracketed to the camera, about two apparent feet from your subjects. What aperture should you choose for average subjects?

SOLUTION: With the wide-flash adaptor, your basic aperture is f8 at two apparent feet.

HOW TO CHANGE FILM SPEEDS

Changing film speeds is easy:
• Each time the film speed is doubled, change the tabled f-stops to the next consecutive higher-numbered stops.
• Each time the film speed is halved, change the tabled f-stops to the next consecutive lower-numbered stops.

As examples, the tabled exposure for three apparent feet and full power for the SB-103 at ISO 100 is f8.
• To change to ISO 25 film, change f8 to f4.
• To change to ISO 50 or 64 film, change the f8 to f5.6.
• To change to ISO 200 film, change the f8 to f11.
• To change to ISO 400 film, change the f8 to f16.
• To change to ISO 800 film, change the f8 to f22.

Note: ISO 50 and 64 are only 1/3 stop apart. You can assume that ISO 64 is the same as ISO 50 in your calculations. If you wish to be more exact, simply close the lens an additional 1/3 stop when using ISO 64.

TESTING YOUR UNDERSTANDING

PROBLEM: You have an SB-103 and have been using the preceding exposure table for manual exposure control with ISO 100 film. You have decided to switch to ISO 200 film for today's dive. Using full power, what are your apertures for apparent distances of three, four and six feet?

SOLUTION: Your new apertures would be f11, f8 and f5.6 for apparent distances of three, four and six feet.

THE BRIGHTEST LIGHT DETERMINES APERTURE

At distances closer than about three to four apparent feet, the strobe usually overpowers sunlight and determines aperture. At longer distances, bright sunlight can overpower the strobe and the sunlight determines the aperture.

At a medium distance of about three or four feet, however, you may be uncertain as to which light source to set the aperture for. Assuming that the sunlight and strobe light are striking the subject from different angles, proceed as follows:

1. Take an exposure meter reading to determine the sunlight aperture.
2. Look at the strobe exposure table to determine the strobe aperture for the strobe-to-subject distance.
3. Set the lens for the highest-numbered aperture of the two.

For example: If the exposure meter reads f8 and the strobe exposure table reads f5.6, set the lens for f8 because sunlight has overpowered the strobe.

TWO EQUAL LIGHT SOURCES FROM SAME ANGLE

What if two equal light sources—such as direct sunlight, and direct strobe light—illuminate the same subject area? Because twice as much light is available for the exposure, a smaller aperture is required. *Determine the aperture you would use with one light source, then close the lens one additional stop.* (See diagram on following page.)

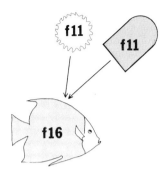

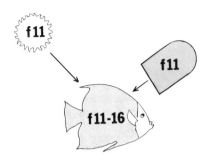

Both strobe and direct sunlight strike the subject from the same angle, and each would provide an f11 exposure. To prevent overexposure, bracket up to f16.

Both strobe and direct sunlight strike the subject from different angles. The basic exposure should be close to f11, but we would bracket to 11-16 to make sure we don't overexpose.

SUNLIGHT IS STRONGER: The ISO 100 sunlight exposure was f11 for this shallow reef scene in the Philippines: the strobe exposure was f5.6. The aperture was set for f11, and the strobe provided fill lighting only.

STROBE IS STRONGER: The ISO 64 sunlight exposure was f5.6; the strobe exposure was f11. The aperture was set for f11 and bracketed to f16 to prevent overexposure of the reflective fish and Cathy's skin tones, and to darken the sunlit background.

USING MANUAL STROBES WITH THE IV-A

Whenever sunlight overpowers the strobe, manual exposure control with the IV-A gets tricky. The glowing/blinking LED display of the exposure control doesn't give you information about apertures and shutter speeds directly. Ideally, you should use a separate exposure meter to easily determine sunlight apertures. The following procedure is as simple as we can make it. It is cumbersome and will require practice.

With a Nikonos IV-A and dedicated strobe, you must turn the strobe off when using the camera's exposure meter. When a dedicated strobe is turned on and is recycled, the camera's built-in automatic exposure control is turned off because the shutter is locked at 1/90 second. If you wish to use the built-in meter to measure the sunlight, proceed as follows:

1. Set the ISO film speed.
2. Set the shutter speed dial for A (auto).
3. Set the aperture for the manual exposure table f-stop.
4. Turn the strobe off (to turn on the metering system).
5. Look at the LED display. If the light is blinking, turn the strobe back on and take the picture. The strobe light is stronger than the sunlight and will determine the exposure.
6. If the LED is glowing, sunlight may be stronger than the strobe light and may determine the aperture. Adjust the aperture to find the quiver point (page 23, step 6).
7. Open the aperture one and a half stops past the quiver point.
8. Look at the f-number on the aperture scale. (This is the same f-number a separate exposure meter would give you).
9. Compare the f-stop from step 8 to the f-stop on your strobe exposure table. Set the lens for the highest-numbered stop of the two.
10. Turn the strobe back on and take the picture.

With a Nikonos IV-A and non-dedicated strobe:
1. Set the ISO film speed.
2. Set the shutter speed dial for A to activate the built-in meter.
3. Set the aperture for the f-stop from your strobe exposure table.
4. Look at the LED display—if the light is blinking, re-set the shutter speed dial for M90 and take the picture. The strobe light is stronger than sunlight and will determine the exposure.
5. If the LED is glowing, sunlight may be stronger than the strobe light and may determine the aperture. Adjust the aperture to find the quiver point, then open one and one-half stops.
6. Look at the f-stop on the aperture scale and compare to the f-stop on the strobe table.
7. Set the lens for the highest-numbered f-stop of the two.
8. Re-set the shutter speed dial for M90.
9. Take the picture.

USING MANUAL STROBES WITH THE V

The exact steps for using a Nikonos V with manual strobe exposure control depend on if the strobe is dedicated or non-dedicated (see page 37 for definitions):

With a dedicated strobe, follow these steps:
1. Set the ISO film speed.
2. Set the shutter speed for A (auto).
3. Turn on the strobe (this locks the shutter at 1/90 second).
4. Look at the shutter speed display in the viewfinder, and adjust the aperture for the *125 60* display.
5. Look at the lens and see what aperture you have set.
6. Look at the strobe manual exposure table and see what aperture is specified for the strobe-to-subject distance.
7. Set the aperture for the highest-numbered stop of the two (steps 5 and 6 above).
8. Take the picture.

With a non-dedicated strobe, the procedures differ only slightly:
1. Set the ISO film speed.
2. Set the shutter speed for 1/60 second.
3. Adjust the aperture until you see only the *60* display in the viewfinder. Note: You may only be able to get the *30* or *arrowhead* display in dim conditions.
4. Look at the lens and see what aperture you have set.
5. Look at your strobe exposure table and see what f-stop is specified for the strobe-to-subject distance.
6. Set the lens for the highest-numbered stop of the two (steps 4 and 5 above).
7. Take the picture.

USING THE STROBE FOR FILL

When photographing long shots, such as pictures of divers and wreckage, you must use a sunlight exposure to light the distant and background subjects. When using strobe you will want to deliberately keep the strobe weaker than sunlight:
1. Set the aperture for the sunlight exposure.
2. Set the strobe for a lower power setting and hold it far enough from the subject so it will be weaker than sunlight.

HOW TO BRACKET MANUAL EXPOSURES

• If sunlight is determining the aperture, bracket by changing the aperture. If the aperture is f8, for example, you shoot at f5.6, f8 and f11.

• If the strobe is determining the aperture, bracket by changing the strobe-to-subject distance. If the tabled distance is three feet, for example, shoot with strobe-to-subject distances of two, three and four feet.

TESTING YOUR UNDERSTANDING

PROBLEM: You are using ISO 100 film, a Nikonos V and an SB-102 strobe set for M FULL, and have set your film speed dial for A (auto). Your subject is six feet away, on a bright, clear, shallow coral reef such as on the top of page 43. Your strobe exposure table (page 40), adjusted for ISO 100, (page 41) indicates that f5.6 should be the correct aperture. But when you adjust the aperture for the 125 60 display for the sunlight exposure, the aperture on the camera lens is f11. What should you do?

SOLUTION: Take the picture with the f11 aperture. Sunlight has overpowered the strobe and will determine the exposure. The strobe will provide soft fill lighting to enhance details and color.

PROBLEM: You are using a level camera angle to photograph a diver and an angel fish two feet away. (Such as the picture on the bottom of page 43.) Your Nikonos V is set for f11 (the manual strobe exposure for two feet), and you have set the shutter speed dial for 1/60 second. You look into the viewfinder and notice that the underexposure arrow is blinking. What should you do?

SOLUTION: Take the picture. You can ignore the underexposure warning for sunlight because the f11 strobe exposure has overpowered the sunlight.

Chapter V

How to Use Auto Strobes
With Remote Sensors

Here's how an automatic strobe with a remote sensor works: The flash of light from the strobe strikes the subject and reflects back to a remote sensor that is mounted on or near the camera. When the sensor detects that enough light has reflected back for an exposure, it signals the strobe to shut off. Thus, the control is based on flash duration (as it is with TTL).

As for disadvantages: The remote sensor doesn't *know* what lens you are using. The wider the lens, the greater the picture area. However, the sensor only reads a small area in the center (or wherever the sensor is aimed). These systems also limit the number of f-stops you can use, and usually aren't applicable for close-ups.

Automatic strobes with remote sensors can be used with the Nikonos III at 1/60 second or slower, and with the Nikonos IV-A and V cameras at A (auto) if the strobe is dedicated, or at 1/90 second or slower.

Note: The automatic strobe exposure and remote sensor are completely separate from the built-in automatic exposure controls of the Nikonos IV-A and V.

AUTOMATIC APERTURES

Automatic strobes that use remote sensors limit your choice of useable apertures to usually one, two or three f-stops, depending on the ISO film speed selected. These are called auto apertures and are given in the strobe instructions or are on decals attached to the strobes. The Nikon SB-101, for example, has a circular calculator on the handle.

The key point is: For automatic operation, you preset the lens for the auto aperture.

AUTOMATIC RANGE

The owner's instructions, and sometimes notations on the strobe or strobe exposure calculator, will tell you the automatic range. This is the range from the minimum to the maximum distance that the automatic exposure control will function. As a rule of thumb, the maximum auto range for any given auto stop will be the strobe-to-subject distance you would normally use for manual exposure control at full power.

REMOTE SENSOR WITH NIKONOS IV-A

The Nikon SB-101 and most other automatic strobes using remote sensors were designed for use with the Nikonos IV-A. Because all of these strobes are used in the same general way, we will give you a basic procedure:

1. Set the film speed dial for the ISO film speed.

2. Set the shutter speed dial for A (auto).

3. Choose an automatic aperture and preset the lens. The automatic apertures you can choose will be listed in the strobe directions or on a table or dial on the strobe.

4. Aim the camera and strobe at your subject and take the picture.

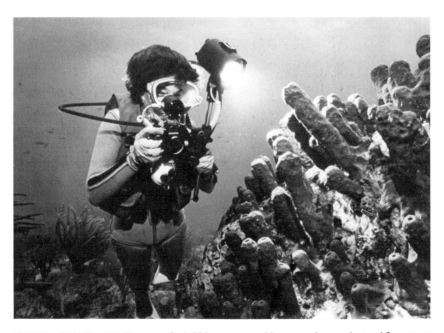

HELIX AQUAFLASH: The Aquaflash 28 has a removable sensor that can be used for remote sensor automatic exposure control with the Nikonos IV-A and earlier models, or with TTL automatic exposure control with the Nikonos V.

Front of Aquaflash sensor has settings for A (auto) with remote sensor, TTL and M (manual), and for sync or slave.

Back of Aquaflash sensor shows automatic apertures, and has ready light and full-power flash (auto check) light.

If sunlight overpowers the strobe at the automatic aperture selected, the picture will be overexposed. Therefore, if you think this may be the case, take an exposure meter reading first. If the sunlight exposure requires a higher-numbered f-stop than the automatic aperture you planned to use, reset for the higher-numbered sunlight f-stop. Your automatic strobe will still provide some color and fill, depending on how powerful it is.

If you don't have a separate exposure meter, and wish to take an exposure meter reading with your Nikonos IV-A, proceed as follows:

1. Turn the strobe off (so the automatic exposure control in the camera body will turn on).

2. Adjust the aperture to find the quiver point, then close the lens by 1.5 stops (see: Using IV-A Auto, page 23).

3. Look at the aperture scale on the lens and see what f-stop you have selected. This is the same f-stop that a separate exposure meter would have given you.

4. Compare the f-stop determined in step 3 to the automatic aperture, and set the lens for the highest-numbered stop of the two.

5. Turn the strobe back on to lock the shutter speed at 1/90.

6. Take the picture.

FINE-TUNING WITH REMOTE SENSORS

Because the sensor doesn't see exactly how much light reaches the film, and doesn't cover the large picture areas of wide-angle lenses, you may need to make some exposure adjustments. If consistently underexposed, use a wider automatic aperture. If consistently overexposed, use a smaller automatic aperture.

TESTING YOUR UNDERSTANDING

PROBLEM: *You are using an automatic strobe with a remote sensor. For the film you are using, the instructions tell you to use an f8. Because conditions are quite bright, you take an exposure meter reading and see that the sunlight exposure is f11. What should you do?*

SOLUTION: *Set the aperture for f11 because the bright sunlight requires the f11 exposure. If you set the aperture for f8, sunlight will overexpose your picture by one f-stop.*

PROBLEM: *Your automatic strobe instructions say to preset the aperture for f8, and to be within four feet of your subject (within the automatic range). Your exposure meter shows that the correct exposure for sunlight is f8, but your subject is six feet away. (a) What f stop should you use? (b) What should you do if the sunlight exposure should be f5.6?*

SOLUTION: *(a) Don't worry about exceeding the automatic range in this case. Because f8 is also the correct exposure for sunlight, your exposure will be O.K. The strobe will add soft fill lighting to enhance shadow details and colors. (b) Use the f5.6. Since the strobe is putting out all of its light at this far distance you can now think of it as a manual strobe. You need to open one stop when you go from four feet to six feet, so the strobe and sunlight will be balanced.*

REMOTE SENSOR WITH NIKONOS V

Although the Nikonos V was designed for use with TTL strobes, you can use a non-TTL automatic strobe with a remote sensor with the Nikonos V:

1. Set the film speed dial for the ISO film speed.
2. Set the shutter speed dial for A (auto).
3. Preset the aperture for the automatic stop listed in the directions. For example, the calculator dial of the Nikonos SB-101 gives you a choice of two automatic stops for each film speed.
4. Look at the shutter speed display in the viewfinder. If the display shows a shutter speed of *125 60* or slower, and you are within the auto range, the strobe is determining the exposure and you can take the picture.
5. If the viewfinder display shows a higher speed than *125 60*, the sunlight is determining the exposure. Close the aperture until the higher speeds disappear. Otherwise, sunlight will overexpose the picture.

Whenever you are using 1/90 second (auto) and wish to increase the background exposure slightly, you can switch to a manual 1/60 setting.

TESTING YOUR UNDERSTANDING

PROBLEM: You are using a Nikonos V with a dedicated automatic strobe and remote sensor. You have set the shutter speed dial for A, and the aperture for the f-stop recommended by the strobe manufacturer. You look at the shutter speed display in the viewfinder and see 250 125. *What should you do?*

SOLUTION: The 250 125 *display indicates that to avoid overexposure, you should use this faster shutter speed with the aperture you've selected. Therefore, because your shutter is locked at 1/90 second, close the aperture until you get a* 125 60 *or slower shutter speed display. Your strobe will provide fill with the sunlight exposure.*

EXPOSURE ADJUSTMENT WITH SB-101

With the Nikonos SU-101 sensor for the Nikonos SB-101 (and optional for the SB-102), we routinely *close the recommended automatic aperture by two additional stops.*

NIKON SB-101:
The Nikon SB-101 and remote sensor shown with a Nikonos IV-A. The sensor has a two-position switch on the back for the two automatic stops. The circular calculator on the handle gives both automatic and manual apertures.

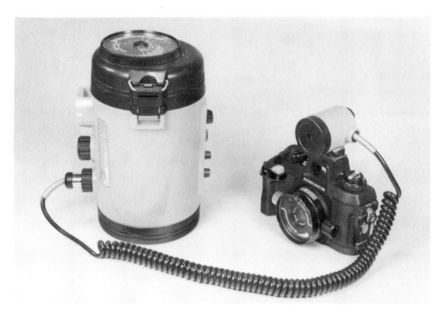

The SB-102 has a sensor port for using the SU-101 sensor with a Nikonos IV-A or older Nikonos camera.

Chapter VI
How To Use TTL Strobes

We know that you'd like to take your automatic camera and strobe underwater, choose any f-stop, and just take pictures automatically at distances of about two or three feet or more. However, it isn't quite that easy. You still need to know how to use the TTL control, and how sunlight will affect your pictures. *Thus, we assume that you have already read about sunlight exposures in chapter III.*

WHAT IS A TTL STROBE

An automatic strobe with TTL (through-the-lens) automatic exposure control is the best choice if you want automatic. The burst of light from the strobe reflects from the subject back through the camera lens and strikes the uncovered film. A built-in meter reads the light reflecting off the film and signals the strobe to turn off when enough light has struck the film for the exposure. Thus, the strobe exposure is determined by flash duration.

Because the TTL metering system inside the camera measures the light reflecting on the film in the central picture area, the picture area measured is relative to the picture area covered by the lens used. With a wide-angle lens, a larger subject area is measured by the TTL than with a 35mm lens.

The camera can be set for a range of f-stops, either at specified stops or between them, when used with a TTL strobe. The TTL also automatically compensates for filters or for exposure compensation with extension tubes.

53

With TTL (through-the-lens) exposure metering, strobe light reflecting back from the subject passes through the camera lens and strikes the film for the exposure. A built-in sensor measures the light reflecting off the film and signals the strobe to shut off when enough strobe light has reached the film for an exposure. The TTL works at any aperture that is wide enough to admit sufficient light for the exposure. This method is also called OTF (off-the-film) metering.

TTL AUTOMATIC RANGE

How far can you be from your subject? When using TTL, the automatic exposure control has an automatic range (called the *coupling distance* in the Nikon manuals). The range is from the minimum to the maximum strobe-to-subject distances at which the TTL can be used.

• The minimum automatic range will usually be about one apparent foot, unless you are using wide apertures with fast films.

• To estimate the maximum automatic range, look at the full power column of the exposure table shown below. For any given f-stop, read the corresponding distance in the Distance column. This apparent distance is the maximum automatic range because the corresponding f-stop is for a full powered flash.

ESTIMATED EXPOSURE TABLE, NIKON SPEEDLIGHT 103 ISO = 100			
Distance	Full power	1/4 Power	1/16 Power
1 foot	f22 (16*)	f11 (8)	f5.6 (4)
2 feet	f11 (8)	f5.6 (4)	f2.8 (2)
3 feet	f8 (5.6)	f4 (2.8)	f2 (1.4)
4 feet	f5.6 (4)	f2.8 (2)	-- --
6 feet	f4 (2.8)	f2 (1.4)	-- --

*Exposure with SW-103 wide-flash adaptor over strobe reflector.

As examples:
• With an aperture of f5.6, and without the optional wide-flash adaptor, the automatic range would extend to approximately four apparent feet.
• With an aperture of f5.6, but with the wide-flash adaptor over the strobe reflector, the automatic range would be approximately three apparent feet.

While reading this chapter, keep in mind that the Nikonos V TTL metering system is center weighted. This means that the meter is influenced mostly by the brightness reflecting back from the center of the scene. Thus, your main subject should fill the central picture area. (This differs from the metering pattern of the sensor for sunlight exposures which is lower-center weighted. See page 31.)

TESTING YOUR UNDERSTANDING

PROBLEM: When does TTL work best?

SOLUTION: TTL exposure control works best with subjects of average reflectance that are large enough to fill the central picture area, and which are within the automatic range of the TTL system.

PROBLEM: You wish to use ISO 100 film and TTL exposure control with the SB-103, without the wide-flash adaptor. Your aperture is set for f4. Approximately how far is the strobe's automatic range (see exposure table, page 54)?

SOLUTION: The automatic range will be six feet, the full power distance for f4.

THE FULL-POWER FLASH SIGNAL

Your TTL strobe may have a full-power flash signal, such as a blinking ready light or audio signal just after the strobe has flashed, to tell you that the strobe has flashed at full power. If you see this signal, you may have exceeded the automatic range, and may have underexposed your picture.

THE BLINKING VIEWFINDER WARNING

With some TTL strobes, the lightning bolt ready light in the viewfinder will blink (rather than glow) when the strobe is recycled if you make one or more of the following errors:
• The strobe is set for TTL and the Nikonos V is incorrectly set for B or for M90.
• If the Nikonos V film speed dial is set faster than ISO 400 (the highest useable film speed with TTL).
• If the strobe is set for TTL with a Nikonos IV-A.

USING TTL IN BRIGHT CONDITIONS

TTL exposures in bright conditions may be overexposed for two reasons:
1. Bright sunlight often overpowers the strobe at distances greater than three to five apparent feet, and even closer if you use upward camera angles. Whenever sunlight overpowers the strobe, you must set the aperture for the sunlight exposure even if are using a TTL strobe. Otherwise, sunlight will overexpose your picture.
2. If direct sunlight illuminates the same subject area, from the same angle as the strobe, the combination of the brief TTL strobe exposure and the longer sunlight exposure can cause overexposure. The flash of light from the strobe strikes the subject and reflects back for the TTL exposure. The shutter, however, remains open for a full 1/90 second for additional sunlight exposure. *The TTL strobe and sunlight exposures are added together. This can double the amount of light striking the subject, causing the overexposure.*
(See diagram, page 43.)

Note: The combined TTL strobe and bright sunlight overexposure problem hasn't been mentioned in owner's manuals at this writing, nor have we heard of any manufacturer's method of compensation. Our *Church Correction* for avoiding such overexposure (increasing the ISO film speed setting, and selecting a faster shutter speed display) is included in the following steps:

How to use the *Church Correction* for using TTL in bright conditions:
1. Set film speed dial for *double the ISO film speed actually* used.
2. Set the shutter speed dial for A (Auto).
3. Set the strobe for TTL.
4. Turn the strobe on (this locks the shutter at 1/90).
5. Make sure the strobe ready light display (the lightning bolt in the viewfinder) is glowing. (If blinking, see page 55.)
6. Turn the aperture control until the *250* and *125* are both blinking. This is the correct aperture for the sunlight exposure at 1/90 second. If your subject has bright areas that sunlight could overexpose, adjust the aperture until you see only the *125* display.
7. Check the focus and take the picture.
8. If the strobe signals a full-power flash, you are probably beyond the automatic range of the strobe. But don't worry, you will have a pleasing sunlight exposure with strobe fill.

• Because you doubled the film speed, the TTL system *thinks* that you only need half as much light for an exposure. Thus, it shuts the strobe off early which reduces the amount of strobe exposure.

• Adjusting the aperture for the *250 125* shutter speed display (although the shutter is locked at 1/90 second) compensates for the increased film speed setting. The *250 125* display is the correct exposure for sunlight when the ISO setting is doubled.

• If you adjust the aperture for the *125* display, you reduce the sunlight exposure by a half stop to avoid overexposing bright subjects.

Note: In bright sunlight, when you set the aperture for the sunlight exposure, and reduce strobe output by increasing the ISO film speed setting, you are making *flash fill* exposures. The higher the ISO film speed you set on the film speed dial (relative to the actual ISO film speed used), the weaker the strobe fill. But don't forget to compensate when metering with the built-in meter by setting the aperture for a higher shutter speed display.

TESTING YOUR UNDERSTANDING

PROBLEM: You doubled the film speed setting and used the 250 125 *display, as explained above, but your pictures taken in bright water are still overexposed. What should you do?*

SOLUTION: Look at your pictures carefully. If the strobe has overexposed, use a higher ISO film speed setting. If the sunlight exposure is overexposed, adjust the aperture for the 125 *display for a half stop reduction in exposure, or for the* 60 30 *display for a full stop reduction.*

OTHER CAUSES OF OVEREXPOSURE

• If the bottom of the picture area is darker than a midwater subject and the distant background, the *correct* viewfinder display may lead to overexposure because the automatic system has opened the aperture to lighten the darker bottom area. Compensate by tilting the camera slightly upward when taking the meter reading.

• If the viewfinder display shows shutter speed displays that are faster than the display you should be using (such as *500 250* rather than *250 125*), sunlight will overexpose the picture.

• Small, bright subjects, such as the yellow butterflyfish found in Hawaii, may not fill enough of the sensing area of the center-weighted TTL system to have a significant effect on the automatic exposure control. The system will average these small subjects with a larger area of distant, dark background. Thus, the smaller subjects will be overexposed. Because TTL doesn't work well in this situation, change to manual exposure control as follows:

1. Reset the film speed dial for the correct ISO film speed.

2. Adjust the aperture for the *125 60* display.

3. Set the strobe for a lower power setting. With Nikon strobes, use 1/4 power in bright condition and 1/16 power in dim conditions.

If the reflective, yellow fish don't fill the sensing area of the TTL, or are closer to the camera than the main subject, the TTL could be fooled into overexposing the picture. Either (a) use manual exposure control with the strobe set for a low power setting, or (b) set the ISO film speed dial for a higher film speed than you are actually using.

HOW TO DARKEN TTL BACKGROUNDS

Suppose that you wish to darken the distant background to accentuate your near subject. To do this, you simply underexpose the sunlight exposure and use your TTL strobe to light the near subject. This technique is easy—you can use your viewfinder display to estimate how dark (underexposed) the background will be.

Here's how to darken the background:
1. Begin by adjusting the aperture for the correct viewfinder display for a sunlight exposure.
2. Close the aperture by one stop to darken the background by one stop.
3. Close the aperture by two stops to darken the background by two stops.

• Since the strobe is now determining the exposure, a full-power flash signal indicates that you can't close the aperture any more without the risk of underexposure.

• You usually must work close—about three feet or less—to darken backgrounds. The greater the amount of sunlight, the closer you must get because the strobe must be strong enough to overpower the sunlight. Close-ups (see Chapter IX) often have dark backgrounds.

Work close and close the aperture to darken TTL backgrounds. Also, see photo on bottom of page 43.

WHY USE A SEPARATE EXPOSURE METER

If you have a separate, direct-reading exposure meter, such as the Sekonic Marine Meter II, you may find it easier to use than the built-in metering system of the Nikonos IV-A or V. You can attach the meter to the camera strobe bracket, hold the camera about a foot in front of your face and scan the scene. You read the metered f-stops for various parts of the scene as easily as you read the speedometer of a car.

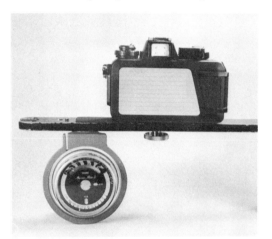

The Sekonic Marine Meter can be placed in an Oceanic Meter Mount, and attached to the 1/4-20 threaded hole in the Nikonos bracket. This method is especially handy when you are using an accessory optical viewfinder — you don't become confused by having to view the subject through the camera viewfinder for exposure and the accessory viewfinder for composition.

Here's how to use a separate meter, (assuming that you are using our bright water correction and ISO 100 film):

1. Set the separate exposure meter for ISO 100, the film speed actually used.

2. Set the camera film speed dial for ISO 200 (rather than 100).

3. Set the shutter speed dial for A.

4. Set the strobe for TTL.

5. Turn the strobe on (locks shutter at 1/90 second).

6. Set the aperture for the separate exposure meter reading—ignore the viewfinder display!

7. Take picture.

Because you set the ISO film speed dial for 200 rather than for the ISO 100 film you are using, the TTL strobe output is reduced by one f-stop. Because you set the aperture for the ISO 100 separate exposure meter reading, your sunlight exposure will be correct. The result is a sunlight exposure with strobe fill lighting to accent color and show details.

If you want weaker TTL strobe fill, set the film speed dial for a speed higher than 200. The markings (not the consecutive numbers) on the film speed dial are at one-third stop increments.

USING TTL IN AVERAGE TO DARK CONDITIONS

While we all like to dive in clear, bright water, conditions can vary from average to dark. In darker conditions, particularly during night dives, when sunlight doesn't overpower the strobe, the viewfinder display may show only a *30* or just the arrowhead underexposure signal. Since there isn't enough sunlight, your strobe must provide most or all the light for the exposure.

Your job is to decide on an f-stop. Start by looking at the exposure chart you attached to the side of your strobe. Assuming ISO 100 film and an Oceanic 3000 TTL strobe, Oceanic's recommended exposure table is as follows:

ESTIMATED TTL EXPOSURE CHART, OCEANIC 3000	
Strobe-to-subject distance up to	Suggested f-stop
1 1/2 feet	22
2 1/3 feet	16
3 1/3 feet	11
4 2/3 feet	8
6 2/3 feet	5.6

Find the aperture for the furthest strobe-to-subject distance you will use. If, for example, your subject appears to be about three or four apparent feet away, set the lens for f8. The automatic range extends to about 4 2/3 feet.
• If you set for a wider aperture—such as f5.6—the automatic range would be extended to 6 2/3 feet, but depth of field would be reduced.

To sum up:
1. Set the film speed dial for the ISO film speed.
2. Set the shutter speed dial for A.
3. Set the strobe for TTL.
4. Estimate maximum strobe-to-subject distance.
5. Set the aperture for the aperture for your maximum strobe-to-subject distance.
6. Take picture.

TESTING YOUR UNDERSTANDING

PROBLEM: You've finally made it to Truk Lagoon. You see some small dishes lying on a dark brown bottom. The dishes have some growth, but appear to be light and reflective. You wish to photograph them with your TTL strobe at about two feet with ISO 100 film. What should you do?

SOLUTION: Look at your exposure table and set the aperture for the manual aperture for two apparent feet. However, because the dishes are small, and the TTL system could respond to the darker brown bottom and overexpose the lighter dishes, bracket with the film speed dial: Make TTL exposures with the dial set at ISO 100, ISO 125 (one mark past 100), ISO 160 (two marks past 100), ISO 200 and ISO 320 (one mark past ISO 200). One of these exposures should be within one-third stop of the correct exposure for the dishes. The dark bottom may have to go dark.

Dishes in the *Shinkoku Maru*, Truk Lagoon. TTL exposure with Nikonos V film speed dial set for ISO 200 with Professional Ektachrome 100. Also, see overexposure problems on page 63.

OVEREXPOSURE PROBLEMS IN DARK CONDITIONS

Even in dark conditions, your TTL strobe may lead you to overexposure: For example, imagine that your subject is a diver wearing an average to dark wetsuit, that the background is dark, and that there isn't enough sunlight for an exposure.

• The TTL system *sees* mostly the dark suit and dark background. It wants to lighten these dark subject areas to average brightness.

• The divers face and hands (assuming light skin) are only a small part of the darker picture area. When the TTL system averages the dark and light areas and decides on an exposure, the system will tend to lighten the larger, darker subject areas. Thus, highlight areas such as reflective light skin tend to be overexposed.

Thus: If you have small subject areas that are bright and reflective, and larger areas that are dark and less reflective, compensate by setting the film speed dial for double the film speed actually used. Even if your strobe gives a full-power flash signal, resist the temptation to increase exposure.

Dark subject in dark conditions with film speed dial set for ISO 100 with ISO 100 film. The TTL lightened the dark central picture area, but overexposed Cathy's reflective face which was mostly out of the sensing area.

Jim compensated by changing the ISO dial setting from ISO 100 to ISO 200, for ISO 100 film. This reduced the overexposure of the face, but a higher ISO setting (such as one mark past 200) would have reduced the overexposure by even more.

USING 1/60 AND 1/30 SECOND

Suppose you wish to use 1/60 or 1/30 second to maximize the sunlight exposure, and a TTL strobe for fill lighting. Proceed as follows:

1. To weaken the strobe output so it doesn't add too much light to the sunlight exposure, double the ISO setting.

2. To compensate for the increased film speed setting, adjust the aperture to show only the shutter speed selected in the viewfinder; then, open one additional stop.

3. If you exceed the auto range of the strobe, use the actual ISO speed and shutter speed display.

4. Hold the camera extra steady and take the picture.

In dim conditions, the shutter speed selected will glow, and the underexposure warning light may blink in the viewfinder. This indicates a strobe exposure with weak sunlight fill. Proceed as follows:

1. Set the film speed dial for the actual ISO film speed.

2. Set the aperture for the full-power flash distance from the strobe exposure table.

3. Hold the camera steady and take the picture.

USING PROLONGED SHUTTER SPEEDS

Suppose you want to photograph the dark interior of a wreck with sunlight and strobe fill. If you wanted an aperture of about f11 for sharpness and depth of field, the sunlight exposure could take several seconds, so mount the camera on a tripod and try one of the following:

• You can set the Nikonos IV-A or V for A (auto) and use a non-dedicated strobe that doesn't lock the shutter at 1/90 second.

• You could flash a strobe (that isn't connected to the camera) during the long shutter speed of several seconds.

• If you have two Nikon TTL strobes and the Nikonos double connector cord, you can make a long exposure as follows:

1. Set the film speed dial for the ISO film speed.

2. Set the shutter speed dial for A.

3. Turn the left strobe (black cord) off.

4. Set the right strobe (gray cord) for a manual setting.

5. Take the picture.

The reason you shut the left strobe off was to prevent it from signaling the camera to lock the shutter speed at 1/90. The right strobe doesn't send signals to the camera, and its TTL doesn't work when the left strobe is turned off. Thus, you must set it for a manual setting.

Note: Prolonged shutter speeds allow more sunlight to reach the film, but the camera must be braced on something solid and the subject can't be moving. We use a tripod to steady the camera.

WHEN TO USE TTL OR MANUAL CONTROL

Use TTL with subjects of average reflectance that fill the central picture area, and are within the automatic range.

Use manual exposure control whenever:

1. Small, reflective subjects are in the picture.

2. The center-weighted system misses the subject and reads the distant background.

3. Some subject areas (such as fish) are close to the camera and others are far away.

4. You wish to light selectively for particular subject areas.

5. You use fancy lighting techniques such as extreme side lighting or backlighting.

• Therefore, we strongly recommend that you master manual exposure control even if you have a TTL strobe.

An upward view of corals and growth on the *Fujikawa Maru*, Truk Lagoon. Taken in bright conditions with a Nikonos V set for A (auto) and ISO 200 for Fujichrome 100 film. Note: Film speed setting was doubled to prevent accidental overexposure by combination of strobe and bright sunlight.

LEFT: Cathy poses by colorful sponges at Cane Bay Gardens, St. Croix, U.S. Virgin Islands. Nikonos IV-A set for f5.6 and M90, and Subsea Mark 100 strobe.

BELOW: The galley of the *Fujikawa Maru*, Truk Lagoon. Nikonos V set for A (auto) and ISO 100 for Professional Ektachrome 100. TTL exposure with twin SB-103 strobes with wide-flash adaptors. Because the subject area is of average reflectance, no exposure compensation was needed.

Chapter VIII
How To Use 35, 28 & 80mm Lenses

Each lens has its own personality, and *gets along* with different subjects. Thus, the key to buying a lens is to first decide what subjects you want to photograph. Then, select a lens that will photograph those subjects at the closest distance possible.

WHAT STROBE SHOULD YOU USE

Most normal-beam strobes cover the picture area of the Nikonos 35mm lens, and the central picture area of the 28mm lens. If you are using a 28mm lens, you may decide to use a wide-beam strobe or a wide-flash adaptor (diffuser) to widen the beam of a normal-beam strobe.

UW-NIKKOR 35mm f2.5 LENS

The Nikonos 35mm lens has always been standard equipment for the Nikonos camera. At a distance of three apparent feet, it covers an apparent picture area of about two by three feet. (Rather than convert back and forth between measured and apparent distances, we believe it is less confusing to simply discuss lenses in terms of the apparent distances and sizes that you see underwater.)

The picture area of the 35mm lens is excellent for photographing fish, large anemones or a head and shoulder portrait of a diver. With larger subjects—such as entire divers or groups of divers—you must back off too far from your subjects for pictures that show fine details sharply. You can, however, take good silhouettes at long distances.

The main features of the 35mm lens are:
• It can be used in air as well as underwater.
• It is the least expensive of the Nikonos lenses.
• At this writing, there are more lens accessories—such as wide-angle adaptors, close-up lenses and extension tubes—available for the 35mm lens than for the other lenses. A 1:1 extension tube with a 35mm lens is an excellent combination for photographing very tiny subjects.

As for disadvantages: Blurry photos and poor composition due to camera movement is a major problem with the 35mm lens (and narrow lenses in general), especially as compared to lenses as wide as the 20mm lens. Also, the relatively small picture area limits your choice of subjects. Serious U/W photographers rarely use 35mm lenses except with close-up lenses or extension tubes.

Depth of field can be a serious problem. When focused for four feet, and the aperture set for f5.6, depth of field with a 35mm lens is only about 3.5 to five feet.

Nikonos 35mm lens set for f5.6 and 4 feet (1.2 meters). Note the shallow depth of field—from about 3.5 to slightly less than five feet.

AIMING THE 35mm LENS WITH THE IV-A VIEWFINDER

The built-in viewfinder of the Nikonos IV-A is for the 35mm lens and is tricky to use:

1. The frame lines inside the viewfinder show only 85 percent of the actual picture area. Thus, subjects will appear larger in the viewfinder than they will be recorded on film. And your photo composition will be altered.

2. The control panel for the LED display juts up into the picture area. Many photographers mistakenly use the top of this panel to frame the bottom edge of the picture, or simply aim by placing their subject's image

28mm lens: Fish and corals in the Red Sea. Taken with Nikonos III and Subsea Mark 100 strobe on Professional Ektachrome 64.

35mm lens: Sleeping shark in a cave at the Kona Coast, Hawaii. Nikonos V set for A (auto) and ISO 100 for Fujichrome Professional 100 (RDP). SB-102 TTL exposure with wide-flash adaptor.

LEFT: 28mm lens: Jeff Leicher and a small moray eel, Kona Coast, Hawaii. Nikonos V set for A (auto), metered to darken background two stops, film speed dial set for ISO125 for Agfachrome 100 Professional Color Slide Film to prevent SB-102 TTL (with wide-flash adaptor) from overexposing small, light skin areas.

BELOW: 28mm lens: A turtle photographed during a night dive in the Red Sea. Nikonos III set for f8 and 1/60 second. Oceanic 2001 strobe and Professional Ektachrome 64.

on top of this panel. If your subjects are too high or their tops are cut off in your pictures, this could be the cause of your problem.

3. The red LED light (for the automatic exposure control) should appear at the right end of the panel when your eye is correctly aligned with the viewfinder. If you center the LED, you will incorrectly aim the camera slightly to the left. If the right edge of your subject is missing, this is your problem.

For best results, disregard the frame lines—assume that everything you see in the viewfinder is in your picture. Adjust your aim so you see the LED at the right side of the panel and keep in mind that the panel is actually blocking out your view of the lower part of your picture. Although it is instinctive to do so, don't tilt the camera to see the bottom of the picture area as you trigger the shutter.

• Also, read the section on accessory viewfinders, page 72.

WRONG!
LEFT: Distant subject placed on top of LED panel.

RIGHT: Camera tilted to show bottom of picture area.

CORRECT!
LEFT: Disregard LED panel when centering vertically.

RIGHT: Picture area at minimum distance.

AIMING THE 35mm LENS WITH THE V VIEWFINDER

The built-in viewfinder of the Nikonos V is for the 35mm lens. It is slightly larger than the IV-A viewfinder and the panel for the LED display doesn't jut up as high in your field of view, but it does cover much of the bottom of your picture area. Because the frame lines in the viewfinder show only about 85 percent of the true picture area, small subjects will appear larger in the viewfinder than they will appear on film.

To keep from having too much empty area around your subject, move in until the subject appears too close to the edge of the frame. Make note of how *wrong* the picture looked as you shot. When you look at the processed film, determine if you estimated correctly.

• Also, read the section on accessory viewfinders.

TESTING YOUR UNDERSTANDING

PROBLEM: You have been using the built-in viewfinder of your Nikonos IV-A or V with your 35mm lens, and your subjects are shown consistently too high in your processed slides. What is the problem?

SOLUTION: When viewfinding in dim U/W light, you accidentally used the top of the LED panel to frame the bottom of your picture. Thus, you aimed the camera too low. Remember that the bottom of your picture area is below the panel!

HOW TO USE ACCESSORY VIEWFINDERS

Most viewfinders are tilted slightly so the lines of sight of the viewfinder and lens meet several feet in front of the camera. This is called *parallax correction*, and is usually accurate enough. Nikon optical viewfinders have markings inside to show the top of the picture area at minimum focus.

• If your accessory viewfinder doesn't have a parallax correction, simply aim a few inches above the intended center of your subject when you are closer than three feet. At longer distances, a few inches of error won't be noticeable.

• With adjustable viewfinders, we suggest presetting them for about four apparent feet and correct for closer distances by aiming a few inches high. Center your subject in the finder, then aim one inch higher for three feet away, and two inches higher for two feet away.
 Changing the adjustment for each shot can be an annoying task, and can not be done quickly as your subject changes distance. You will be busy enough making other changes without having to change the viewfinder too. With a little practice a quick change of aim is fastest.
 Also, adjustable viewfinders can slip out of adjustment, or you may forget to change the adjustment when you change distances.

• If your viewfinder shows more area than will be included in your picture, mask it off so that it will not influence your view of the subject as you compose.

Nikon plastic U/W viewfinder for 35mm and 80mm lenses. The outer frame is for the 35mm lens; the inner frame is for the 80mm lens: the peep sight in the center is for centering subjects and to help you look straight through the finder. This viewfinder is parallax corrected for approximately six apparent feet. At close distances, aim a couple inches above the intended center of your subject.

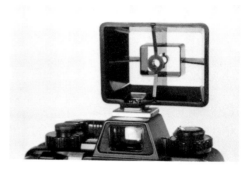

Nikon hard rubber viewfinder for 28mm lens. This model doesn't have the peep sight of the 35/28mm finder (above), and isn't parallax corrected. We suggest aiming a couple inches above the intended center of your subjects. This is a difficult finder to use as it is easy to look through it at an angle and misframe your subject. When attaching this viewfinder to the camera for the first time, grease the bottom with a dab of silicone grease.

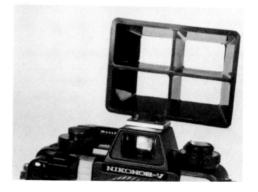

Nikon optical 28mm viewfinder with optional mask for 35mm lens. This viewfinder has parallax correction marks for minimum focus, is parallax corrected for approximately six apparent feet and shows approximately 90% of the actual picture area.

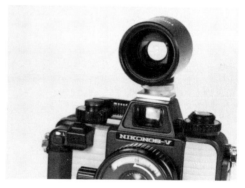

TOO BIG AND TOO FAR

The most common mistake beginners make with 35mm (and 28mm lenses, as well) is to try to take pictures of scenic views with two or more divers in the picture. They must get so far away from their subjects with the 35mm lens, that the subjects lose contrast, color and detail.

• If you want to photograph scenics and large subjects, you need a wide-angle lens as discussed in Chapter VIII.

UW-NIKKOR 28mm f3.5 LENS

The Nikonos 28mm lens was designed exclusively for U/W photography. Look at the front port at an angle and you will see that it is concave. This is because it isn't simply a glass *window* as with the 35mm lens. The 28mm lens port is optically corrected on both sides for U/W photography. In air, lines in the corners are not straight. (If you do not have important items in the corners, the pictures may appear fine.)

At three apparent feet, the 28mm lens covers a picture area of about 2.5 by 3.75 feet. This allows you to photograph larger subjects with sharper detail than with the 35mm lens. For smaller subjects, you can focus down to two feet as compared to 2.75 feet with the 35mm lens.

The 28mm lens is excellent for photographing large fish, eels, turtles and other sea life at two apparent feet or larger animals such as sharks, dolphin or rays that you can't get close to.

As for disadvantages, fewer accessories, such as wide-angle adaptors, close-up lenses and extension tubes are available for the 28mm lens, but more of these accessories are appearing on the market.

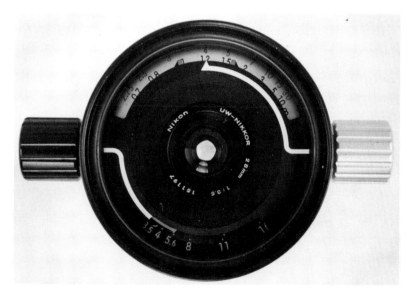

Nikonos 28mm lens set for f5.6 and four feet (1.2 meters). Note the depth of field is about two feet. Compare this to the 35mm lens on page 68. The front glass port is optically corrected to eliminate U/W picture distortion.

TOO SMALL AND TOO CLOSE

The second most common mistake is to use a 35mm or 28mm lens to photograph tiny subjects about one to two feet away. With the 35mm lens, you are too close for sharp focus and the subject is usually too small for your picture area. The 28mm lens will focus at two feet, but a tiny subject usually won't carry the picture. (This usually happens because of the SLR syndrome, page 76.)

• If you want to photograph small, close subjects, use close-up lenses as described in Chapter IX.

HOW TO ESTIMATE PORTRAIT DISTANCE

Estimating three apparent feet for diver portraits is easy with the *fingertip-to-fingertip* method. The steps are as follows:

1. Preset the focus for three feet.

2. Hold the camera in your right hand and look at your diver subject over the top of the camera.

3. Extend your left arm and point your fingertips toward your subject.

4. Your subject extends his/her arm toward you and touches fingertip to fingertip.

5. You both lower your arms, and you take the picture.

When you and your subject are fingertip to fingertip, the distance from the film plane of your camera to your subject will be within a couple inches of three apparent (four measured) feet. Take care that neither of you moves after taking the measurement.

• Other methods of measuring distances are to use a cord or stick.

• Beginners often get too close to their subjects with their 28 or 35mm lenses—if you can reach out and touch your subject, you are much too close.

PRACTICE WITH A YARDSTICK

Jim's favorite method of estimating distance is to train the eye to recognize a camera-to-subject distance of three feet. To train your eye, hold a yardstick in your left hand and your camera in the right hand. Holding the yardstick slightly behind you, so you can't see it, aim your camera at any object in the room. Aim from an estimated distance of three feet from the film plane (not the front of the camera), then quickly measure the actual distance with the yard stick.

• Practice with different sized objects, and with different camera angles. Within five minutes, you should be able to estimate three feet within a couple inches each time.

• Once you can estimate three feet, four feet is only one-third further away, and two feet is only one-third closer.

You must practice with the yardstick before each photo dive because you will lose much of your ability to estimate distance accurately if you don't practice. Don't worry about the differences in apparent and measured distances. You are training your eye to recognize three feet as you see it. Don't take the yardstick underwater—it will appear to be only 3/4ths of a yard.

AVOID THE SLR SYNDROME

If you have been using an SLR (single-lens reflex) camera topside for several years, you may forget to adjust the focus when using a Nikonos IV-A or V. Because these cameras have a similar appearance and feel to topside SLR cameras, you may subconsciously think that the focus is correct if the subject's image appears sharp in the viewfinder. Don't be fooled. The Nikonos viewfinder is for aiming only. Images in the viewfinder will always be sharp, regardless of the distance you set the lens for.

CHOOSING FILM FOR 35mm & 28mm LENSES

An ISO 100 film is a good choice for U/W photography in reasonably clear water, such as you might find around warm Caribbean or Pacific islands. It can be used topside as well as underwater for both normal picture taking and close-up photography.
 • If you are having trouble estimating distances, ISO 200 film will give you more depth of field because you can close the lens by an additional f-stop. This is especially helpful with the 35mm lens.
 • In dim conditions, such as deep dives, dark wreck interiors or cloudy days, ISO 400 or faster films may be needed.

NIKKOR 80mm f4 LENS

The Nikonos 80mm lens has only limited usefulness for U/W photography. With a picture angle of about 22 degrees, it is best for taking close-ups of small creatures that you can't approach. You take your close-ups from about four apparent feet away. However, there are some big problems:
 • You must estimate distances accurately. At four feet and f11, depth of field is less than six inches.
 • With sunlight exposures, 1/125 second is the minimum shutter speed you should use to avoid excessive blur from camera movement.
 • To photograph a critter in its lair, place the camera on a tripod, and measure (16 measured inches equals one apparent foot) the distance from the subject's lair to the film plane of the camera. When the creature peeks out, take the picture.

• With the Nikonos Close-up Kit, you can photograph a picture area of about two by three inches, at a distance of about nine inches. While this may sometimes give you a preferred perspective, it is often better to get closer to the subject with an extension tube. If the creature will tolerate the Close-up Kit framer, it should tolerate the extension tube.

Note: We believe that the 80mm lens is best used as a semi-telephoto lens for your topside shots. An accessory optical viewfinder is available for topside photography.

The 80mm lens is a good, waterproof telephoto lens for boaters or others who need a water-proof camera. Focus range is from 3.5 feet to infinity; aperture range is from f4 to f22.

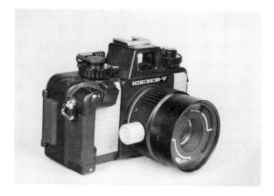

A Bermuda Chub photographed at 3.5 apparent feet with an 80mm lens. The fish is about one foot long.

An optical viewfinder, with adjustable parallax correction, is available for topside use.

LW-NIKKOR 28mm f2.8 LENS

Designed for topside use, this lens is water-resistant, not watertight. Thus, it is a splash-resistant lens recommended for boaters and those who photograph in a wet environment and need a water-resistant lens. Warning: It is not intended for U/W photography.

This lens has two depth of field indicator lines: blue for f11 and orange for f22. The small red dot (located near the larger white index for the focusing scale) is for setting focus with infrared film.

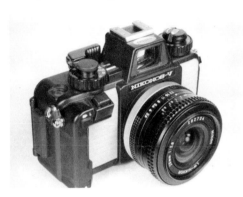

Aperture range: f2.8 to f22; focus range: 1.5 ft. to infinity. Use all of the image shown in the viewfinder when composing. At infinity, with your eye 20mm away from the viewfinder, you see about 91 percent of the actual picture height and 95 percent of the picture width. At 1.5 feet, use the upper (infinity) frame line in the camera viewfinder for parallax correction.

The LW-Nikkor 28mm lens (shown above) takes sharp topside photographs. The picture area is significantly greater than the image in the viewfinder when your eye is held close to the viewfinder. Both this photo and the photo below were taken with a Nikonos V mounted on a tripod, at f16 and 1/250 second, on Kodak Tri-x.

The UW-Nikkor 28mm lens (shown and described on page 74) doesn't do as well above water. Although you can take casual above water snapshots with this lens, the pictures are not as sharp — especially in the corners.

Chapter VIII

How To Use
Wide-angle Lenses

Wide-angle lenses are great for medium and large subjects, such as divers, U/W scenics and wrecks. With a 35mm or 28mm lens, you would have to photograph such large subjects from too far away. Getting closer to your subjects reduces the amount of water (and suspended particles) between camera and subject, and reduces the loss of contrast and color as light passes through the water.

Even smaller subjects, such as a diver from the waist up, will be sharper if you use a wide-angle lens to get closer to your subject. This is especially true in turbid water where there are more particles.

The biggest problem you will have with a 20mm or 15mm lens for the first time is that it is addictive. Once you have used one, you will want one.

A WIDE-BEAM STROBE IS NEEDED

Wide-beam strobes are needed to cover the picture areas of wide-angle lenses. Normal beam strobes can only be used for highlighting particular subject areas.

UW-NIKKOR 20mm f2.8 LENS AND VIEWFINDER

The 20mm lens is an excellent portrait lens for both head and shoulder portraits and pictures of an entire diver. Beginning photographers may find this lens easier to handle than wider lenses. It is wide enough to allow you to get close to large subjects, but not so wide that you have trouble visualizing the final results. There will be less empty space around the subject with the 20mm lens compared to the 15mm lens.

The 20mm lens differs from the other Nikon lenses in that the focus and aperture scales are on the control knobs, and the respective index marks are on the lens mount. The scales are easy to read—simply tilt the camera back and look down at the top of the lens mount. Three color-coded depth of field markings are provided: yellow for f4, orange for f5.6 and red for f11. Depth of field is excellent. At three feet and f5.6, for example, depth of field extends from about two to almost six feet.

Accessory threads are provided for 67mm filters. However, Nikon warns that filters may cause vignetting (rounded picture corners because the filter ring shows up in the picture).

Both the 20mm lens and viewfinder are designed exclusively for U/W use and will produce blurry images in air. The lens can be used with any model Nikonos camera body, and can be used with the automatic metering systems of the IV-A and V.

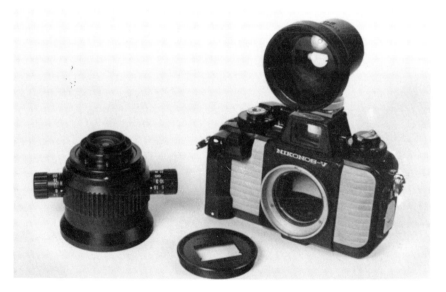

ABOVE: 20mm lens, camera body and 20mm viewfinder. The mask is for the 28mm lens. Aperture range: f2.8 to f22. Minimum focus: 1.3 feet. Parallax corrected for about 4.5 apparent feet 20mm lens and six apparent feet with the 28mm lens. Parallax marks are used for minimum distance.

Viewfinder shows about 85% of actual picture area.

LEFT: aperture and focus scales are on the control knobs. Depth of field indicators are provided for f4, f5.6 and f11.

UW-NIKKOR 15mm f2.8N LENS

The 15mm wide-angle lens enables you to take pictures of larger subjects at even closer distances than with the 20m lens. For wide-angle close-ups, the 15mm lens can be focused down to one foot and covers a picture area of about 1.5 by two feet. It is the sharpest, most distortion-free lens of its angle that we have ever used underwater.

• The focus and aperture controls are easy to operate. With the camera held in your right hand, the focus control knob is on the left side, and the aperture control is at the lower left.

• The scales for aperture, focus and depth of field are beneath a curved port at the upper right of the base of the lens mount. Both aperture and focus settings are aligned with a single black dot on the scale. It is easy to determine depth of field with the large moving indicators.

• By merely tilting the camera back and a bit to your left, and looking downward to the curved port, the settings can all be seen in one glance.

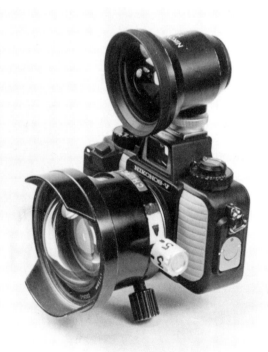

New-style 15mm lens and viewfinder. Aperture range: f2.8 to f22; minimum focus: one foot (.3m). The viewfinder is parallax corrected for approximately 4 1/2 apparent feet (1.5m), and has parallax correction marks for two feet (.6m) and one foot (.3m). Note: Focus scale (laundry marker on tape) on focus control knob is easy to read in dim light.

FOCUSING FOR WIDE-ANGLE PICTURES

Because of the extraordinary depth of field with the 15mm lens, you can zone focus for fast action if you don't have time to change focus while photographing. For example, with an aperture of f/5.6 and a focused distance of three feet, depth of field extends from slightly less than two feet to about ten feet. As with any lens, don't zone focus if you have the opportunity to set the proper focus. Even with a wide angle lens, the focused distance is still the sharpest distance.

If you have a wide-angle lens, study the changes in depth of field as you change distance and aperture. When focused for one foot and f11 with a 15mm lens, your total depth of field is less than 11 inches. If you move the focus to two feet, depth of field extends from 1.1 foot to infinity. Try other combinations of distance and aperture to become more familiar with depth of field.

When you have both near and far subjects, and want both to be equally sharp, set the focus for one-third the distance past the near subject. *For example, if one diver is three feet away, and another is six feet away, set the focus for four feet.* However, if you have other close foreground subjects, don't set the focus so that the far depth of field indicator exceeds infinity— this sacrifices near depth of field.

15mm OPTICAL VIEWFINDER

The newest 15mm optical viewfinder is smaller than the previous model, and doesn't have a yoke that covers the built-in viewfinder of the camera body. Thus, the full LED displays of both the IV-A and V camera bodies are unobstructed. The new viewfinder can also be used with the I, II and III camera bodies.

Because the viewfinder optics are corrected for underwater use, you will see blurry images if you look through the viewfinder in air. And if you aren't expecting this, it could cause your heart to skip a beat or two if you have just unwrapped your new viewfinder and are looking through it for the first time. Likewise, the lens is also corrected for underwater use and would produce blurry pictures in air.

OLD-STYLE 15mm LENS

The old-style 15mm UW-Nikkor lens was designed for use with the Nikonos I, II or III. It is more compact than the new style 15mm lens because the lens elements protrude so far back inside the camera body.

• Although the old-style lens can be used with a Nikonos IV-A or V camera body, the protruding lens elements block the internal light paths of the automatic metering systems.

• If you are using a separate exposure meter to measure sunlight, and manual or non-TTL automatic exposure control for a strobe, the old style lens works quite nicely with the IV-A or V.

OLD-STYLE 15mm VIEWFINDER

This large viewfinder, designed for use with the 15mm lens and Nikonos I, II and III, is truly a joy to use underwater. It produces large, bright and sharp images, and you see 90 percent of the actual underwater picture area the lens covers. Thus, because the actual area is slightly greater than what you see, you are less likely to amputate part of your subject. But on the other hand, you are more likely to make the error of photographing your subject from too far away.

The old-style viewfinder had a vertical yoke attachment that covered the viewfinder and LED displays of the Nikonos IV-A (and later, the Nikonos V). Thus, a modified version appeared: An indentation was made on the left side of the vertical yoke, so you could see the IV-A LED display. When using the automatic exposure control of the IV-A, lower your eye downward, in line with the left side of the viewfinder yoke, and you will see the red LED inside the viewfinder. This procedure, however, isn't always easy.

Old-style 15mm lens and viewfinder shown with Nikonos III. This model was more compact because the lens elements protruded further back inside the camera body. The viewfinder provided a large viewing area.

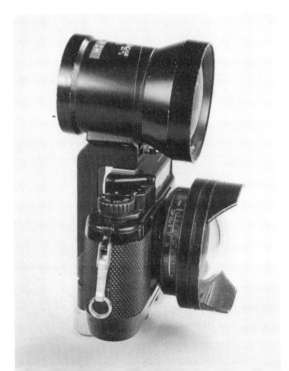

LEARNING WIDE-ANGLE VIEWFINDING

Learning to use your wide-angle viewfinder will take some practice. The key points to remember are:
1. Compose through the viewfinder.
2. Scan the viewfinder from corner to corner.
3. Fill the viewfinder with subject.
4. Remember to check the built-in viewfinder for exposure information.
5. Remember that parallax corrections do not compensate for perspective corrections. (See far and near subjects, page 86 and taking the wide-angle close-up, page 93.)

The new 15mm viewfinder (page 81, 82) has parallax adjustment markings for 1.5m (4.5 feet), 0.6m (2 feet) and 0.3m (1 foot).

The old-style viewfinder (page 83) didn't have parallax markings, but had a larger viewing area.

Although the new 15mm viewfinder has parallax marks for wide-angle close-ups, remember that the camera lens sees the subject from a different (lower) perspective than your eye.

THE COMMON 15mm VIEWFINDING ERROR

The most common mistake is to compose an U/W picture by eye as you look at the subject over the top of your viewfinder, then raise the camera and use the viewfinder as a *gun sight* to point the camera at the center of your subject. This is a mistake because your eye sees the subject with the perspective of a 50mm lens, and when you take that picture with a wide-angle lens, you won't get the picture you wanted. You will have taken the picture from too far away! Your subject will be too small, other subjects may clutter the corners of the picture, and you will lose both color and sharpness because of the increased distance.

Compose while looking through the viewfinder! Move in close and fill the viewfinder from corner to corner with desired subject area. Don't take the picture until you have composed it completely in the viewfinder.

TESTING YOUR UNDERSTANDING

PROBLEM: Your subjects appear too small and too far away in your 15mm pictures. The pictures lack drama and impact.

SOLUTION: Get closer and fill the viewfinder with subject. Look at everything in the viewfinder, from corner to corner. Take a picture at your normal distance. Move in closer and take another picture. Take a picture when you think you are a little TOO close, and finally one when you feel you are MUCH TOO close. Study your results.

WRONG: Because the photographer was staring at the fish's image in the viewfinder, and ignoring all else, the fish is lost in the background.

CORRECT: Move in closer until you fill the viewfinder with subject. Look at the picture area shown in the viewfinder from corner to corner. Remember that you are only seeing 90% of the actual picture area.

VIEWFINDING FOR NEAR AND FAR SUBJECTS

Aligning near and far subjects—such as a near porthole and a distant diver—requires a special viewfinding technique. The camera must be lifted so the lens sees the same view that you saw through the viewfinder.

• One technique is to first compose the picture in the viewfinder, and then lift the camera so the back of the camera body is centered in front of your eye. (See page 93.)

• Or, compose the picture in the viewfinder and then raise up about four inches as you continue looking through the viewfinder.

It doesn't matter what technique you develop, as long as the lens sees the same view as you originally composed in the viewfinder.

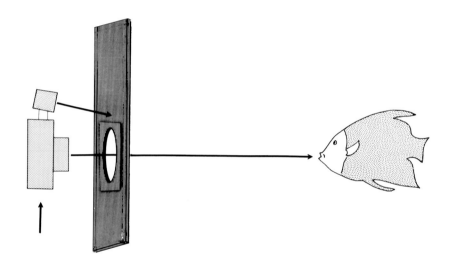

When photographing a distant subject through a near porthole, the parallax correction markings in the viewfinder can't be used. You must lift the camera so it sees the correct view of the subject.

CHOOSING FILM

We try to use a film that will produce apertures of at least f5.6 at 1/90 second, with level camera angles, at depths of about 30 feet. In clear, bright water, ISO 50 or 64 can usually be used. Assuming that conditions aren't always optimum, ISO 100 is a good all-around choice. And for darker conditions, ISO 200 or 400 is often used. We don't use the faster films unless they are needed for dark conditions.

TAKING THE WIDE-ANGLE SILHOUETTE

Wide angle silhouette shots are usually taken with sunlight and upward camera angles, although level camera angles can be used to silhouette divers in the openings of tunnels or archways.

If you are using a model to accent a scene, have the model look at the scene through your viewfinder. This helps the model relate to the scene as they pose.

The steps for taking wide-angle silhouettes are:
1. Get settled and tentatively compose the picture in your wide-angle viewfinder.
2. Take an exposure meter reading of an area of average brightness and set the aperture. (See Chapter III)
3. Set the focus for the main subject and check that depth of field includes both far and near subject areas if both must be sharp in the picture.
4. If using an upward camera angle, exhale and wait a few seconds for your bubbles to clear the scene. Also, look for bubbles rising from leaks in your SCUBA equipment.
5. Check that bubbles haven't formed on the lens port.
6. Signal the model to begin whatever action you've planned.
7. Compose the picture in your viewfinder.
8. Take the picture.

Cathy and the *Cayman Diver*, Grand Cayman, BWI.

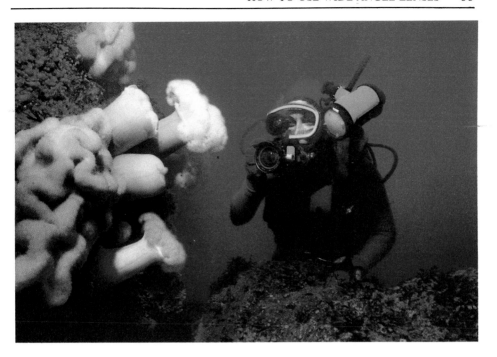

COMPARISON OF 20mm (above) AND 15mm (below) LENSES: Both pictures were taken at three apparent feet in the turbid water of Monterey Bay, California. Nikonos V and a single SB-103 with wide-flash adaptor; manual exposure control at full power and f5.6 on Professional Fujichrome 100.

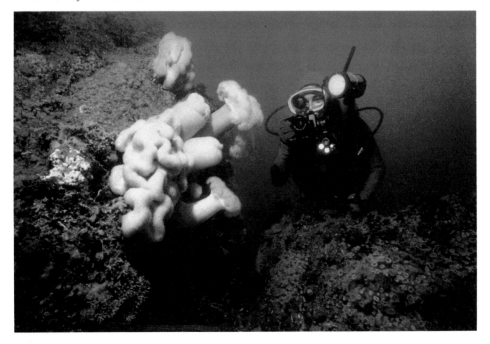

TAKING THE WIDE-ANGLE SCENIC

Wide-angle scenics are usually sunlight exposures taken with strobe fill to bring out details and color in the foreground. The standard procedure is to begin with a sunlight aperture setting, and to use strobe fill (about a third to a full stop weaker than sunlight) on near subject areas.

The steps for taking wide-angle scenics are:
1. Set Nikonos IV-A for M90; set Nikonos V for A (auto).
2. Set aperture for the sunlight exposure. (See Chapter III.)
3. Set the focus for maximum depth of field.
4. For manual exposure control, look at your manual strobe exposure table and see what strobe-to-subject distance is listed for your sunlight aperture. Hold the strobe about one-foot further from the subject than the tabled distance. (This reduces the amount of strobe light by about one stop.)
5. For TTL exposure control: If the closest subject area is beyond the automatic range, set the film speed dial for the correct ISO film speed. If small subjects (such as small fish) are within the automatic range, double the ISO film speed setting to avoid accidental overexposure. (See page 56.)
6. Compose the picture in your viewfinder.
7. Take the picture.

Wide-angle scenic at Dry Rocks, B.V.I. Nikonos V set for A (auto) and ISO 200 for Professional Ektachrome 100; SB-102 set for TTL and with wide-flash adaptor.

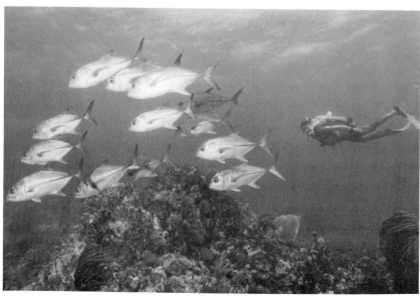

TAKING THE WIDE-ANGLE PORTRAIT

The wide-angle portrait usually shows a diver relating to the sea life, exploring, or even taking a picture. Portraits are often taken at apparent distances of three feet or less.

To emphasize and accent the subject, it is often best to use strobe lighting that is stronger than sunlight, thus the background is darkened.

Whenever possible, discuss the poses and pictures with your model ahead of time. If any action or movement is involved, tell the model to look at the action or movement. If, for example, a fish swims through the scene, the model should look at the fish—not the camera. Generally, the model should look toward the side of the picture where the strobe will be. This assures that the face will be illuminated.

The steps to taking wide-angle portraits are:
1. Set up the basic pose.
2. Take an exposure meter reading and set an aperture that darkens (underexposes) the sunlight background by about a half stop or more.
3. Estimate distance carefully and set the focus for the model's face.
4. With manual exposure control, look at your manual strobe exposure table and hold the strobe at the tabled distance for your sunlight aperture.
5. With TTL exposure control bracket to less exposure by increasing the film speed dial to avoid overexposing light skin tones.
6. Compose the picture in your viewfinder.
9. Take the picture.

Wide-angle portrait of Cathy with a butterfly fish at the ring on the foremast of the *RMS Rhone*, B.V.I. Nikonos IV-A set for M90 and f5.6; Subsea Mark 100.

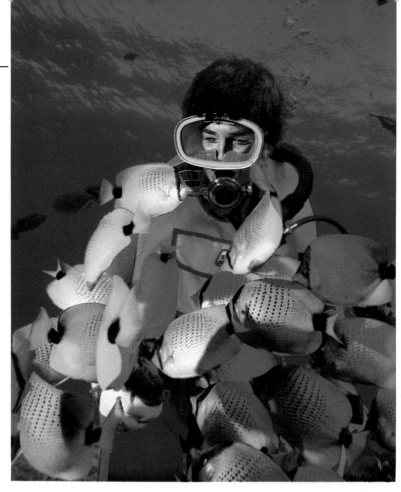

You can use the wide-angle 15mm lens for a variety of portrait styles. UPPER LEFT: Close portrait captures interaction between diver and fish at Molokini Crater, Hawaii. Nikonos V, SB-103 and manual exposure control. Professional Ektachrome 64. LOWER LEFT: Medium distance portrait emphasizes the broad expanse of seafans in the U.S. Virgin Islands. Professional Ektachrome 64. BELOW: Far portrait includes two divers photographing the vertical columns of the *Balboa*, Grand Cayman, B.W.I. Nikonos V, Subsea Mark 100. Professional Kodachrome 64.

TAKING THE WIDE-ANGLE CLOSE-UP

If you have a wide angle lens that focuses down to about one foot (0.3 meters), you will enjoy wide-angle close-ups. Choose a film/strobe combination that will allow you to use at least an f11. With the lens set for minimum focus, you can take pictures with near subjects about eight inches in front of the dome port. To estimate distance use the span from your thumb tip to the tip of your little finger.

Often, you will not get the picture you want if you simply aim the viewfinder at the subject—even if you correct for parallax. This is because the lens views the subject from a different angle than the viewfinder.

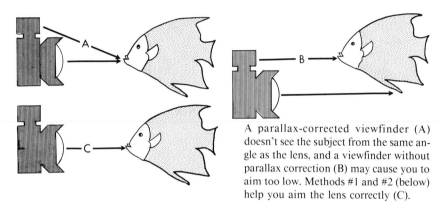

A parallax-corrected viewfinder (A) doesn't see the subject from the same angle as the lens, and a viewfinder without parallax correction (B) may cause you to aim too low. Methods #1 and #2 (below) help you aim the lens correctly (C).

If you want the lens to see the same view you saw through the viewfinder, use one of the following methods:

Method #1: While topside, place a small white dot on the back of the camera body (or the yoke of an old-style 15mm viewfinder) that corresponds with the lens aperture. Underwater, compose through the viewfinder, then raise the camera vertically. *When the white dot is in front of your eye, take the picture.* Be careful not to tilt the camera backward or forward as you lift.

Method #2: Remove the viewfinder and use it to compose the picture. Holding the viewfinder steady, move your head back one or two feet and see exactly where you are holding the viewfinder. *Lay the viewfinder down and hold the camera at the same position where you held the viewfinder.* Take the picture.

With either method, hold the strobe about a foot above the camera, aiming down at about 45 degrees to the subject. Be careful that the strobe beam doesn't strike the dome port and cause reflections or flare.

COMBINING CLOSE-UP AND LONG-DISTANCE SUBJECTS

You can make interesting photographs by combining a wide-angle close-up subject with a distant subject in the same picture. The three key elements will be viewfinding, focus and lighting.

Because you must align close-up and long-distance subjects in the picture, viewfinding is tricky. Review pages 86 and 93.

Often the depth of field is limited to either the close subject or the far one, but not both. You must set the focus for the main subject—either far or near. The main subject should be the most interesting part of the scene, the area with the greatest contrast, the most color, or the brightest area. (See page 82.)

TESTING YOUR UNDERSTANDING

PROBLEM: You are photographing a diver through a near porthole that is drab and ugly. Should you focus for the porthole or the diver, and should you use strobe light to accent the porthole?

SOLUTION: Focus for the diver; and if possible, get some strobe light on the diver. By keeping the porthole dark and softly out of focus, your picture will be a diver portrait framed by the porthole.

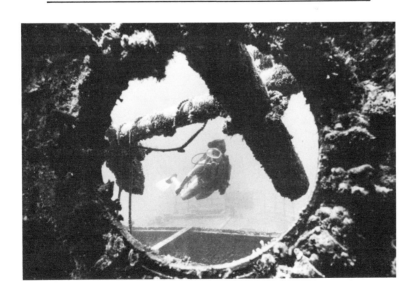

Combined close-up and long-distance subjects taken through a porthole at the stern of the *RMS Rhone*, in the B.V.I., with a 15mm lens set for two feet and f16. Nikonos V set for M90; SB-103, with wide-flash adaptor, set for full power. Professional Ektachrome 100.

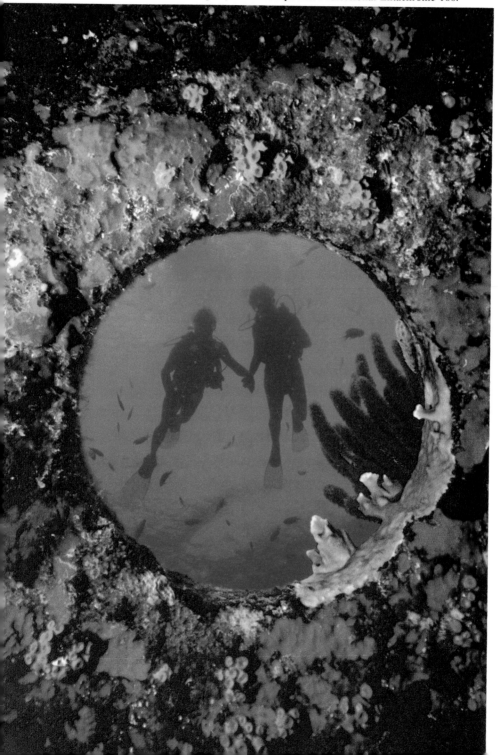

Wide-angle close-up taken with a 15mm lens set for 1.25 feet and f8. Cathy and Garbonzo the eel, at Molokini Crater, Hawaii. Nikonos IV-A set for M90 and f8; Subsea Mark 100 set for 100 watt-seconds. Professional Ektachrome 64.

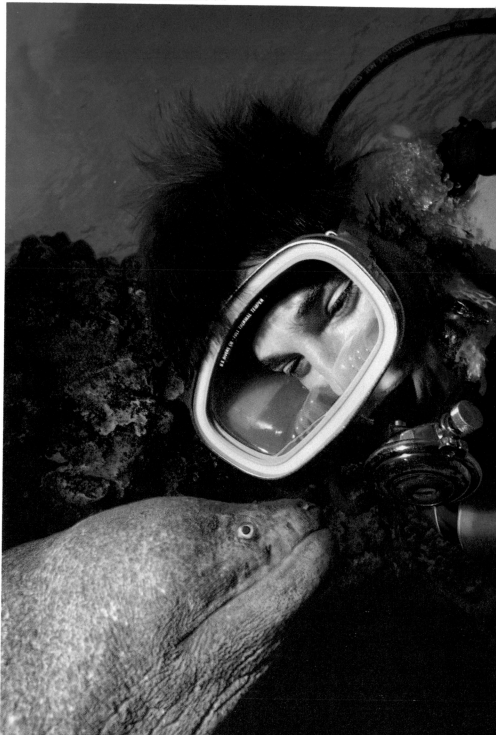

Chapter IX

How To Use
Close-up Lenses

Close-up U/W photography is fun and surprisingly easy to learn. Even beginners can get sharp, colorful pictures quickly. And once you start looking for the smaller subjects, you will begin to see marine life that you never noticed before. Close-up photography differs from normal and wide-angle photography in many ways:

• Close-up subjects, such as a starfish or anemone, are often easier to find and light than large subjects. You can settle on bottom and work all the angles with a stationary subject.

• Poor visibility causes fewer problems because you are working close to your subjects. You can often take close-ups on days when dirty water would make U/W photography difficult at longer distances.

• Many close-up subjects, such as red or orange hermit crabs, are more colorful than long scenic views or pictures of distant divers.

• Strobe exposures are generally easier to control at close distances.

WHAT STROBE SHOULD YOU USE

A normal-beam strobe (one that covers the picture area of a Nikonos 35mm lens) is all you need. It will usually be smaller and lighter, require fewer batteries, and will be less expensive than a larger, wide-beam strobe. Although you may decide to use a TTL strobe, inexpensive strobes with manual exposure control are easy to use for close-ups.

CHOOSING FILM

ISO 25, 50, 64 or 100 films are good choices. Pictures taken with the slower films are often sharper and have better color, but require a more powerful strobe. Many photographers standardize with either ISO 50, 64 or 100.

CHECKLIST FOR TAKING CLOSE-UPS

The following list of steps applies to all close-up lenses for the Nikonos camera:

Before the dive:
1. Attach the strobe and test flash with the camera shutter release.
2. Load the camera with film, and set the ISO dial.
3. Preset the aperture (page 111 for TTL, 114 for manual exposure control).
4. Preset the focus (infinity for the Nikonos Close-up Outfit, minimum distance for most others—see instructions with lens.)
5. Preset the shutter speed for strobe photography (A for TTL, M90 or 1/60 for manual).
6. Attach the close-up equipment.

In the water:
7. Flood the space between the close-up lens and the camera lens. (The Nikon Close-up Outfit has slots for self-flooding, but check for bubbles on the lens.)
8. Turn the strobe on.
9. Find a subject that fits the lens, and get yourself stationary.
10. Determine your lighting angle and hold the strobe about twelve inches from the subject.
11. Compose the subject in the framer or under the wand.
12. Take the picture.

USE MEASURED DISTANCES

It's easier to use actual measured distances for close-ups rather than the apparent distances you use underwater for photography at longer distances.

CLOSE-UP DEPTH OF FIELD

Depth of field is the range of distance—in front of and behind the focused distance—where subjects look sharp enough to appear in focus. Depth of field with close-up lenses is very shallow—a few inches at most. Therefore, be sure that the main point of interest in your close-up picture is at the correct distance from the camera where it will be sharply focused. The viewer will tolerate blur in other unimportant areas.

• If you photograph fish or any other creature with eyes, for example, focus for the eyes. As long as the eyes are sharp, legs, tails or antennae can often be blurred.

RIGHT: A lemon butterfly fish accepts a handout at Lanai, Hawaii. Nikonos V with 28mm lens set for f22 and Nikon Close-up Outfit; SB-103 strobe set for full power. Professional Ektachrome 100.

BELOW: A starfish in Monterey Bay, California. Nikonos V set for A (auto) with 28mm lens set for f16 and Nikon Close-up Outfit. SB-103 set for TTL. Professional Agfachrome 50.

LEFT: A spotfin butterfly fish photographed during a night dive in Grand Cayman, B.W.I. Nikonos IV-A on M90 with 35mm lens set for f22, Nikonos Close-up Outfit and Oceanic 2001 strobe. Professional Ektachrome 64.

BELOW: A spanish dancer photographed during a night dive in the Red Sea. Nikonos IV-A on M90 with 35mm lens set for f22, Nikonos Close-up Outfit. Two strobes: Oceanic 2001 for main lighting and Oceanic 200S (slave) for fill. Professional Ektachrome 64.

• Using f22 gives about one-third more depth of field than f16; but at the exact focused distance, f16 (or f11, depending on the lens) produces a sharper image. With f22, the increase in depth of field improves the overall impression of sharpness and is usually worth the sacrifice of better sharpness at the point of focus. If, however, you are photographing something flat, you may wish to use f16.

CLOSE-UP DEPTH OF FIELD				
REPRO.	PICTURE		APERTURE	
RATIO	AREA (inches)	f/11	f/16	f/22
1:10	9.4 x 14.2	2.42	3.52	4.84
1:8	7.6 x 11.3	1.58	2.30	3.16
1:6	5.7 x 8.5	.92	1.34	1.84
1:4	3.8 x 5.7	.44	.64	.88

THE NIKONOS CLOSE-UP OUTFIT

The Nikonos close-up outfit has three main parts: a close-up lens (with support rod) that fits over the Nikonos 35mm, 28mm or 80mm lens; a detachable framer support rod; and a separate field framer for each lens.

The field framers fit around the perimeter of the close-up picture area. There is a 10mm (slightly less than one-half inch) space between the inside of the framer and the actual border of the picture. This space prevents the framer from accidentally showing up in the picture.

The picture areas and reproduction ratios for the close-up lens when used with the 28, 35 and 80mm lenses are:

• 28mm lens = 5.68 x 8.51 inches (1:6).
• 35mm lens = 4.30 x 6.38 inches (1:4.5).
• 80mm lens = 2.09 x 3.11 inches (1:2.2).

The steps for attaching the Nikon Close-up Outfit to your camera are as follows:
1. Begin by attaching the lens support rod to the viewfinder shoe of the camera body.
2. Preset the lens for infinity.
3. Loosen the knob on the side of the close-up lens mount by turning it counter clockwise.
4. Lay the camera body on its back, and gently slip the close-up lens down over the lens and support rod. Wiggle the lens slightly to make sure it is on square.

5. Tighten the knob with firm finger pressure, but be careful not to use too much force. You can damage the screw and threads!

6. With the camera on its back, attach the framer support rod.

7. Attach the appropriate field framer. Note: the indentation on the frame faces back toward the camera. If you apply a very thin coating of grease to the ends of the framer, they will slip in much more smoothly.

USING THE NIKONOS CLOSE-UP OUTFIT

At many dive sites, tame fish can be lured within the framer. Have your dive buddy lure the fish in with small bits of food. Watch your lighting angle—side or top lighting will cause a shadow of the framer to fall on your subject.

Taking close-ups can be a two-person task. Get settled before trying to take pictures.

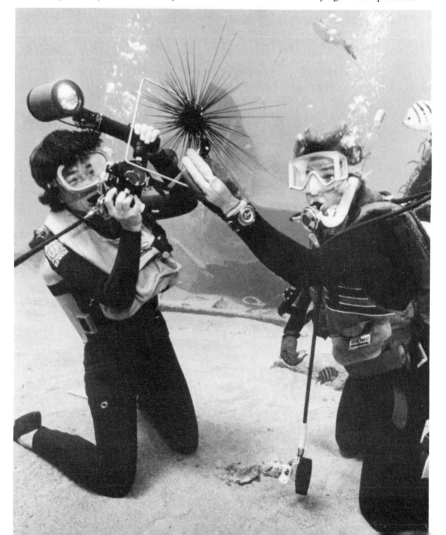

FACING PAGE, TOP: Cathy uses small tidbits of food to lure an angel fish into the 28mm framer of Brian Arena's Nikon Close-up Outfit. Brian's SB-102 is set for 1/16 power and slave, and with a wide-flash adaptor. Jim photographed them with a 15mm lens and a Nikonos V set for ISO 125 for Professional Ektachrome 64, and a SB-102 set for TTL. BELOW: The results of the the technique Brian and Cathy are demonstrating. Nikonos V set for A (auto) and f22, and the SB-102 set for TTL. Professional Ektachrome 64.

While a framer allows accurate aiming, it can bump against the subject or bottom. Thus, if your subject is attached to the bottom or hiding back inside a small crevice, the framer may be impossible to use. Therefore, you will eventually want to use the lens without the framer. You can learn how in three easy steps:

1. Begin with stationary subjects and train your eye to judge the size of the picture area framed.

2. Start removing the framer whenever it gets in the way. You can hold a detached framer up to a subject, and note where the framer support rod would be. Set the framer to one side, (don't lose it!) and aim the camera by placing the end of the support rod where the framer indicated it should be. Keep the camera parallel to the way you held the framer.

3. After you have a feel for the picture area, you can start leaving the framer at home.

When working without the framer, it's easy to use your thumb and first finger to estimate where to place the end of the support rod. Simply touch your left thumb to the support rod, and hold your first finger up to the center of the lens (but don't touch it). Holding your thumb and first finger in this position, place your fingertip at the center of your intended picture area. *Your thumbtip now marks the spot where you should place the end of the support rod.*

The Nikonos Close-up Outfit with Nikonos V and SB-103 strobe. Optically, we believe that this is the finest close-up lens for the Nikonos.

HYDRO PHOTO CLOSE-UP LENSES

Hydro Photo Close-up Lenses screw directly into the accessory threads of the Nikonos lens mount. Models #1, #2 and #3 are for use with the Nikonos 35mm lens, and model 12-28 is for the Nikonos 28mm lens. These lenses are compact, durable and can be put on or taken off while underwater.

Model #1 covers (according to our own tests) approximately a 3 by 4.4-inch picture area, 4 3/4 measured inches from the front of the lens. This particular close-up lens overlaps the approximate picture area of a 1:3 extension tube. It would be best for subjects that you can't fit an extension tube framer around.

Model #2 covers approximately a little greater than a 4 by 6 inch picture area, 8 1/2 measured inches in front of the lens. This is a popular size for giant plume worms, arrow crabs, small fish and a variety of other small subjects.

Model #3 covers approximately a little less than an 8 by 12 inch picture area, 15 measured inches in front of the lens. This is a popular lens for photographing tame fish.

Model 12-28 can be used at three distances: With the Nikonos 28mm lens set for 2 feet, it covers approximately an 8 by 12 inch picture area, 12 measured inches from the lens; with the camera lens set for 6 feet, it covers a 10 by 15 inch area 16 inches in front of the lens; and with the lens set for infinity, it covers a 12 by 18 inch area 20 inches in front of the lens.

When using threaded close-up lenses, be sure to flood the space between close-up lens and the Nikonos lens before you take pictures. If you don't completely flood this space, water may only partially fill the space, and the pictures taken will be partly blurry.

The picture area of the Hydro Photo #2 is approximately 4 by six inches, just below the tip of the wand.

An adjustable Hydro Photo Focusing Wand is available for aiming with the Hydro Photo #1 and #2, and can be used as a sighting device for the #3. Hydro Photo Framers have two steel rods that indicate the left and right sides of the picture area. The HPF35 rods extend to the exact distance for the #1 lens and half the distance for the #2 lens. The HPF28 framer extends half the distance for the 12-18 at the 12 inch distance.

The Hydro Photo close-up lens system is a versatile, compact system. The wand and framers require practice, but they can be used effectively.

AIMING WITH A WAND

A simple focusing wand can be an effective tool, but it will take practice to learn how to use it.

• To help visualize the picture area, find something that you carry while diving that can be used to compare sizes. For example, suppose that you have a Hydro Photo #2, which covers a 4 x 6 inch picture area, 8 1/2 inches in front of the camera. Look at the back of your Nikonos camera body: The width of the IV-A or V camera body is approximately the width of the picture area. The height of the body (to the viewfinder shoe) is approximately four inches. The dimensions of the back of your camera approximate the picture area, and since you can see the camera at a glance you can easily see your picture area underwater.

• To aim a close-up lens (even when using a wand) aim the camera so that the center of the picture area will be directly in front of the center of the lens.

There is supposed to be a small space between the top of the picture area and the tip of the wand, so the wand doesn't accidently show up in the picture. However, since the wand is easily bent, don't depend on it; use it for distance only—not camera aim. Aim the camera by looking slightly from one side and aiming the center of the lens at the center of the picture area. Keep your eye along the sight of the camera so that you can see approximately with the same perspective as the lens.

• If you know the wand is straight, you can aim with it. To estimate where to place the tip of the wand, place your left thumb by the center of

the lens and touch the wand with your first finger. Without changing the space between thumb and finger, place the thumb near the center of your intended picture area. Your fingertip now marks the spot where you should place the tip of the wand.

• To estimate the distance for holding your strobe, look at the wand. It is 12 inches long—a typical strobe distance.

• Look at the camera, not just the tip of the wand, as you aim. In most cases, you should keep the camera parallel to your main subject so that it will all be sharp.

AVOID THE COMMON AIMING ERRORS

• Many divers place the wand above just the subject, rather than above the entire picture area. If the subject is small in the picture, you need more space above it than if the subject were large.

• Many marksmen have an innate tendency to point the wand right at the subject, so only the bottom half of their subject remains in the picture.

• Photographers often judge their composition by the view that they see. If the camera is a foot lower than their eye, the camera may see a significantly different view of the scene. Move your eye close to your camera to check composition.

Using a thumb and forefinger to estimate picture area height. First touch your thumb to the bottom of the camera body, and your finger to the top. Holding the same relative distance between thumb and finger, use your hand to estimate picture height. Place the wand above the fingertip.

PRESS-FIT CLOSE-UP LENSES

Press-fit close-up lenses slip over the Nikonos 35mm lens and are usually held in place by a nylon screw on one side. Use only finger pressure when adjusting the nylon screw—the fit of the lens on the mount shouldn't be too tight.

Keep the following points in mind when using press-fit lenses:

• The space between the close-up lens and the Nikonos lens must be flooded during use.

Framers give a more accurate indication of picture area than a simple wand and help keep the camera parallel to the focus plane. However, they can cast shadows on the subject with side lighting. Beginners, who have used the full framers of extension tubes, may try to use the half frame shown as though it were a full frame.

• If the fit is too tight, it will be difficult to remove the lens underwater. You could move the Nikonos lens enough to break the o-ring seal.

• Before taking pictures, and frequently during the photo dive, gently press the lens in place to make sure that it is properly aligned over the Nikonos lens.

• Use the hole in the close-up lens mount to attach a short cord in case the close-up lens falls off.

• Don't swim around with your close-up lens dangling on a cord. It could be damaged on rock or coral, or could tear loose.

• Avoid close-up lenses with large built-on framers that can not be removed. They cause shadows with some lighting angles, get bent easily, and often get in the way of maneuvering your camera for certain camera angles.

TESTING YOUR UNDERSTANDING

PROBLEM: Some of your close-ups taken with press-fit close-up lenses are sharp, others aren't. What should you do?

SOLUTION: Make sure that the lens is pressed firmly in place before taking pictures, and check the fit frequently.

PROBLEM: Some of your pictures have irregular, out-of-focus areas. What might the problem be?

SOLUTION: The space between the close-up lens and the Nikonos lens may not be flooded properly, and there may be air bubbles on the glass surfaces.

HOW TO PHOTOGRAPH FISH

Suppose you want to photograph fish or eels. You can get close to them, but they aren't tame enough to tolerate your wand or framer. To photograph these subjects, you must learn how to aim your close-up lens by eye alone. The aiming techniques we will give you are easy and accurate.

For simplicity, let's assume that you are using a Hydro Photo T3 close-up lens with your Nikonos 35mm lens. Underwater, it produces a measured 8 x 12 inch picture area, fifteen measured inches in front of your lens, an excellent distance for photographing friendly fish. Once you see how to aim the Hydro Photo T3, you can apply the same techniques to other lenses as well.

There are two ways to estimate distance and picture area. One is to train the eye, the other is to use your hands, arm or camera equipment as an U/W reference. In practice, you will probably use a combination of the two.

By eye: The 15 measured inches will appear to be only 11.25 inches from the front of your lens when underwater, so start by practicing with that distance in air to train your eye. Keep your ruler hidden from view as you try to hold your camera 11.25 inches from an object that is within a picture area that measures 10 1/2 x 16 inches. Check yourself with a ruler.

By practicing in air, you can easily learn to estimate distances within a half inch. Don't worry about apparent vs. measured distances when underwater—use the apparent distances you see. As for picture area, the height and width of the picture area will be approximately twice the height and width of the camera body.

Underwater reference: To use an underwater reference, hold your camera in your right hand. Assuming that your strobe is bracketed to the camera, hold your left arm so it touches the left side of the camera body, extend your fingertips outward until they are fifteen measured inches in front of the lens. Look at what part of your arm touches the camera body. This is your U/W reference. Whenever you extend your arm in the above manner, and touch the camera to the same spot on your arm, you have the measured distance. If you are handholding your strobe, you can use the strobe arm and strobe head in the same manner as you used your arm.

The fish, of course, won't let you touch them with your fingertips or strobe, but you can still use this method. Simply move to the left of the fish and extend your fingertips (or strobe head) outward to get a visual reference for distance. Then, pull your fingertips (or strobe head) back and move the camera to the right to line it up with the fish. Jim swings the

camera in an arc, from left to right, and moves his strobe into firing position as he starts moving the camera.

Aiming the camera is the easy part. Look at the fish and choose an imaginary spot about three inches above its center. With many fish, this will be at or near the dorsal fin. While staring at the dorsal fin (for this example), raise the camera—about six or eight inches in front of your face—and look at the dorsal fin through the camera's built-in viewfinder.

You won't see the entire fish in the viewfinder. You will see its top portion and your imaginary spot on the dorsal fin. You are using the viewfinder as a *pistol sight* to aim the camera.

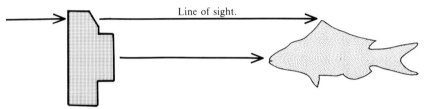

If you can see the framing marks in the viewfinder, center these in the finder. This assures that your eye is in correct alignment with the viewfinder. This aiming technique, combined with estimating distance by eye (page 109) takes practice, but will be effective once you master it.

AVOID THE APPARENT IMAGE ERROR

Don't look down at your subject, such as a fish, and aim the camera by hand/eye coordination. The fish's apparent image that you see is closer than the fish's actual position. Because you are aiming at the apparent image, the fish will be too low in your picture.

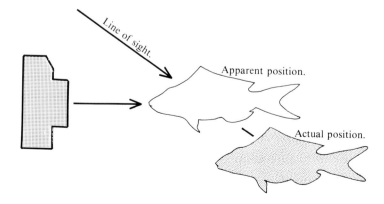

USING TTL FOR CLOSE-UPS

Using TTL is easy for most close-ups. The basic check list is as follows:
1. Set the ISO dial for the film speed used.
2. Set the shutter speed dial for A (auto).
3. Set the aperture (see next section).
4. Set the strobe-to-subject distance (see next section).
5. Aim the camera and take the picture.

OPTIMUM TTL EXPOSURE SETTINGS

The *optimum exposure* is the combination of strobe-to-subject distance and aperture that correctly exposes the film. Ideally, at the optimum exposure setting, *the TTL strobe should be delivering slightly less than a full power flash.*
• If the TTL strobe only delivers a partial flash, it might not be shutting off in time to prevent overexposure. This happens if strobe-to-subject distance is too close or the aperture is too wide.
• If the TTL strobe delivers a full-power flash, it might not be delivering enough light for the exposure. This happens if the aperture is too small or the strobe-to-subject distance is too great.
• By delivering only slightly less than a full-power flash, the strobe shuts off in time, but has some reserve power in case a dark subject requires more light.

Note: If you have determined an f-stop and strobe distance for manual exposure control, you can set the strobe for TTL and hold it a couple inches closer than you would for manual exposure control.

HOW TO USE THE FULL-POWER FLASH SIGNAL

The objective is to find the exact combination of aperture and strobe-to-subject distance at which the TTL strobe signals a full-flash. To do this, you must take three or four *underwater* test exposures. Once you determine when the strobe signals the full flash, you will increase exposure by about 1/3 stop. Thus, the strobe will deliver slightly less than a full-power flash. With high-power strobes, use ISO 50 or 64 film; with low-power strobes, use ISO 100. The test procedure is as follows:

Strobe bracketed in position: Use the aperture control as follows:
1. Set ISO dial for film speed.
2. Set aperture for f22.
3. Set shutter speed dial for A (auto).
4. Adjust strobe-to-subject distance for 12 to 14 measured inches, depending on the strobe arm and bracket.

5. Aim the camera at the subject and take a picture. If the strobe signals a full-power flash, open the lens 1/3 stop and try again. Continue opening the lens by 1/3 stop until the strobe stops signaling a full flash. Then, open the lens an additional 1/3 stop. *This is now your basic aperture for your combination of close-up lens, strobe, strobe-to-subject distance and film speed.*

• **The strobe may be so powerful,** or film speed so high, that the strobe doesn't signal a full power flash with a lens setting of f22 and a strobe distance of 12 or 14 inches. If so, increase the strobe-to-subject distance, place a cloth or diffuser over the strobe reflector or use a slower film, and repeat the test exposures.

Hand-held strobe: Preset the aperture and use strobe-to-subject distance to control exposure as follows:
1. Set ISO dial for film speed.
2. Set aperture for f22.
3. Set the shutter speed dial for A (auto).
4. Beginning with a strobe-to-subject distance that produces a full-power flash (usually 12 to 18 inches), take your first picture.
5. Move the strobe in a few inches closer and take another picture. Continue moving the strobe closer to the subject until it stops signaling a full-power flash. Then, move the strobe in a few inches closer. *This is now your basic strobe-to-subject distance for your combination of strobe, close-up lens, film speed and aperture.*

TESTING YOUR UNDERSTANDING

PROBLEM: You wish to bracket your strobe so it will be 12 inches from your close-up subjects. However, you are confused—should you use measured or apparent distances?

SOLUTION: When using close-up lenses and extension tubes, most U/W photographers used measured strobe-to-subject distances. At longer distances, however, most U/W photographers use the apparent distances their eyes see. Note: One apparent foot equals 16 measured inches.

NO FULL-POWER FLASH SIGNAL

If your TTL strobe doesn't have a full-power flash signal or any close-up instructions, begin with a strobe distance of 12 or 14 measured inches (depending on the strobe arm and bracket). To find the aperture, begin by closing the lens three stops smaller than the aperture you would use at three apparent feet with the ISO film speed selected. Typical three-foot and close-up apertures are shown below:

- f4 strobe at 3 feet = f11 at 12 measured inches.
- f5.6 strobe at 3 feet = f16 at 12 measured inches.
- f8 strobe at 3 feet = f22 at 12 measured inches.
- f11 strobe at 3 feet = f22 at 16 measured inches.

Take some underwater test exposures:
- If you bracket the strobe in place, make test exposures at half-stop intervals, such as f16, f16-22 and f22. If you have a 3-ft, f11 strobe, and wish to use it at 12 inches, place a diffuser (or cloth) over the reflector to make it a 3-ft, f8 strobe.
- If you wish to hand-hold the strobe, make test exposures at about 9, 12 and 16 inches.
- Have the slides processed, then evaluate your exposures to see what strobe distance worked best.

TESTING YOUR UNDERSTANDING

PROBLEM: You have no instructions for using your TTL strobe for close-ups. But the manual exposure table shows that f8 should be used at three apparent feet with ISO 64 film. Your strobe doesn't have a full-flash signal. How do you determine what exposure settings to use for TTL close-ups with the same ISO?

SOLUTION: Start with f22 (three stops less exposure than the f8 for three apparent feet,) and a strobe distance of 12 measured inches. Bracket at 9, 12 and 16 inches. Examine the slides to verify that 12 inches is the correct distance.

BRACKETING TTL EXPOSURES

You may wish to bracket your TTL exposures to adjust for differences in reflectiveness and brightness. You do this by changing the ISO film speed dial setting. *For more exposure, use a lower setting. For less exposure, use a*

higher setting. The amount of exposure change required will be something you will learn from experience. Each mark between the film speed numbers on the dial equals one-third of an f-stop.

Dark subjects: If the overall subject is extremely dark, the TTL will tend to lighten the subject to produce an average exposure. For example, when top lighting a large eel, you may want the mouth and underside to stay in dark shadow, with only the top of his head and eyes highlighted. The TTL would respond to the large shadow area and try to add more strobe light to the picture. This would overexpose the top of the eel. To keep the main area dark, set the film speed for at least double the ISO film speed.

Light subjects: If a subject is extremely bright overall, the TTL may tend to darken the subject to an average exposure. For example, suppose you wanted to backlight some fire coral, producing extremely bright highlight areas in the center. To keep them bright, set the film speed for at least half the ISO film speed.

Average to bright subjects: If your subject is mostly of average reflectance, but has small bright areas with fine details, an average exposure might overexpose the bright areas. To prevent such overexposure, set the film speed dial one mark (one-third stop) higher than the actual ISO film speed used.

• If your TTL exposures are consistently overexposed, set the film speed dial for a higher ISO film speed than you are actually using. And if your TTL exposures are consistently underexposed, set for a lower ISO film speed.

USING MANUAL EXPOSURE CONTROL

The advantage of using manual exposures for close-up photography is that once you have your strobe-to-subject distance established, it doesn't matter where the shadows fall in the picture, your exposures will still be consistent. The disadvantage is that it takes a while to learn the right distance, and you may have to change the distance with each lens and film combination.

Here's how you use manual exposure control.

1. Load with ISO 50 or 64 film with powerful strobes; ISO 100 with medium or weak strobes.

2. Set the shutter speed dial to M90 or 1/60.

3. Hold the strobe about 12 to 14 measured inches from the subject (depending on strobe arm and bracket).

4. Preset focus (see instruction sheet with close-up lens).

5. Preset aperture—usually f16, f16-22 or f22 (see following sections).

6. Aim camera and take the picture.

USING NON-NIKON MANUAL STROBES

If you know what your strobe's f-stop is for three apparent feet, for the ISO film speed you are using, you can estimate your close-up exposures. You may, of course, need to make slight adjustments to fine-tune the exposure for your particular strobe:

- f4 strobe at 3 feet　　= f11 at 12 measured inches.
- f5.6 strobe at 3 feet　= f16 at 12 measured inches.
- f8 strobe at 3 feet　　= f22 at 12 measured inches.
- f11 strobe at 3 feet　 = f22 at 16 measured inches.

USING NIKON STROBES ON MANUAL

We use the following table as a guide to using Nikon strobes, without the wide-angle adaptor, on manual power:

ESTIMATED MANUAL CLOSE-UP EXPOSURES NIKON STROBES				
Strobe used	ISO speed	Power setting	Strobe distance	f-stop used
SB-101	25	full	12 inches	22
	50/64	1/4	12	16
	100	1/4	12	22
SB-102	25	full	12 inches	16
	50/64	full	12	22
	100	1/4	12	16
SB-103	50/64	full	12 inches	16
	100	full	12	22

- If wide-flash adaptor is used (to soften light and widen beam), add one stop of exposure to above exposure guides.

BRACKETING MANUAL EXPOSURES

If the strobe is attached in a fixed position, bracket by changing the aperture. Open the lens a half or full stop for dark subjects; close the lens a half or full stop for light subjects.

If you are handholding the strobe, hold the strobe up to one-fourth closer for dark subjects. Hold the strobe up to one-fourth further back for light subjects.

FINE TUNING MANUAL EXPOSURES

Because the power output of a strobe can vary with the condition of the battery and strobe electronics, and differences in power settings may not be exactly as specified, our exposure advice is only a starting point. You may have to make some slight adjustments in aperture or strobe distances when using manual exposure control. However, once you have learned how to make these adjustments, you will be able to easily control the light intensity of the highlight areas, regardless of where the shadows fall in your picture.

TESTING YOUR UNDERSTANDING

PROBLEM: You are about to use a close-up lens for the first time. What f-stop and strobe-to-subject distance should you use, and how should you bracket? (With the film you will be using, you know that f5.6 seems to be the best f-stop for your strobe at three apparent feet.)

SOLUTION: Closing down three stops from f5.6 (your three-foot f-stop), set the lens for f16 and hold the strobe 12 measured inches away. To bracket with aperture, you can maintain the same strobe distance and vary the aperture. To bracket with strobe distance, maintain the f16 aperture and make exposures with strobe-to-subject distances of about 9, 12 and 16 inches.

Chapter X

How To Use
Extension Tubes

An extension tube is simply a metal cylinder that you place between the Nikonos 35mm or 28mm lens and the Nikonos camera body. The front of the tube is machined to accept the lens, and the rear of the tube is machined to fit into the camera body. Its purpose is to shorten the focused distance of the lens to only a few inches.

Extension tubes allow you to photograph tiny subjects that are too small to photograph with close-up lenses. This opens an entirely new and colorful undersea world as you can now bring back pictures of tiny creatures that many divers have never even seen. Learning to use extension tubes is fun and easy.

When you use an extension tube, you aim the camera with a framer. Most framers show the bottom and sides of the picture area, but the inside is larger than the picture area. The purpose of this clearance between the framer and the picture area is to prevent the framer from showing in your picture if the framer were accidentally bent. The amount of clearance varies with the size of the framer and may be 3/8-inch or more with the larger framers.

EXTENSION TUBE SIZES

The four most common sizes are 1:3 (pronounced "one to three"), 1:2, 1:1 and 2:1. The first number (before the colon) refers to the subject's image size on film. The second number refers to the subject's actual life size. This ratio is called the *reproduction ratio* and is used in all areas of photography—not just underwater extension tubes.

• If a three-inch fish produces a one-inch image on film, the image is 1/3 life size. This is a 1:3 reproduction ratio.

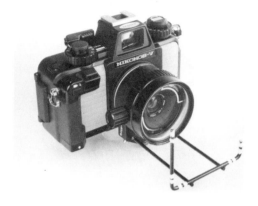

Extension tubes are aimed with focal framers. We have cut off part of the left upright of this framer so we can sidelight without casting a shadow on the subject.

Because a 35mm transparency is approximately one inch high (inside the mount), you can estimate the reproduction ratio of an extension tube by looking at the framer. The height of the framer should be slightly more than the subject's life size.

• A 1:3 framer should be slightly higher than three inches.
• A 1:2 framer should be slightly higher than two inches.
• A 1:1 framer should be slightly higher than one inch.
• A 2:1 framer should be slightly higher than a half inch.

However, don't expect all extension tubes to match these measurements. The specified sizes of extension tubes are often only approximations. Each manufacturer appears to interpret the measurements differently, some use apparent vs. measured inches and some appear to round off irregular measurements. For example, one manufacturer makes a 1:2.7 tube but for simplicity calls it a 1:3 tube. It photographs a smaller picture area than other 1:3 tubes.

TESTING YOUR UNDERSTANDING

PROBLEM: If an extension tube or close-up lens photographs a 4 x 6 inch picture area, what is the approximate reproduction ratio?

SOLUTION: It is 1:4. The height of the 35mm slide is approximately one inch; the height of the picture area is four inches. This is a 1:4 reproduction ratio.

TUBES OR CLOSE-UP LENSES

Extension tubes are for tiny subjects up to about three inches high, and close-up lenses are for small subjects about three to 12 inches high. There is an overlap, however, at about 1:2 to 1:3, where both extension tubes and close-up lenses (pages 101 and 105) can be used.

The common question, "Which is best, an extension tube or a close-up lens," is mostly a question of subject size. Extension tubes are usually for photographing subjects that are too small for close-up lenses. But at the overlap point (in the previous paragraph), extension tubes produce sharper images because there is no added lens in front of the prime lens (the lens on the camera itself). And they produce more depth of field because the effective aperture is smaller than with a close-up lens.

Extension tube framers are easier to use than the wands that are used to aim close-up lenses. However, extension tubes lock you in because they can't be changed underwater. Since close-up lenses can be changed underwater, you can adapt more easily to the types of subjects you find on your dive.

There are lens combinations available that allow you to switch underwater from 1:2 to 1:3 and even to wide-angle 28mm close-ups. Be careful when switching lens accessories underwater, it's easy to get confused and ruin all of your pictures.

35mm OR 28mm TUBES?

There can be confusion as to whether a particular extension tube is for the 35mm or 28mm lens.

The only difference is in the framer. Because the picture areas, and minimum lens-to-subject distances are different with 35mm and 28mm lenses, different framers must be used. Rather than buy different tubes for each lens, look for tubes that can be purchased with both 35mm and 28mm framers. Then, be sure to mark each tube and framer clearly!

Although the 35mm lens takes excellent pictures with extension tubes, the 28mm lens has two important advantages: Being optically corrected for U/W photography, it can produce sharper images; and because the distance from lens-to-subject is reduced by its wider picture angle, there is less water between lens and subject. You probably wouldn't notice the difference in projection, but might see better results if you made large color prints. However, 35mm is often best for 1:1. The 28mm 1:1 framer is so close to the lens that it restricts your strobe lighting angles.

HOW TO BUY AN EXTENSION TUBE

Consider these points when purchasing an extension tube:
• Have the tube installed on the camera at the dive shop. With properly lubricated O-rings, the tube should be close to the fit of the lens on the camera. Don't accept the tube if it must be forced in place.
• A properly-fitting tube will wiggle a little—the longer the tube, the more it will seem to wiggle in air. Underwater, sea pressure will keep it in place.
• Look through the framer at the lens, and look at the lens and framer sideways. The area within the framer should be square to the lens. If the framer is too high, too low or to one side, your pictures will be misframed. Don't buy it.
• Can the framer easily twist or slip out of adjustment? An error of only a fraction of an inch will cause blurry pictures.
• A framer with removable uprights allows you to remove an upright for shadowless sidelighting.
• How durable does the framer appear? If it bends, your pictures will be misframed. Spring uprights are especially fragile.
• Can you remove the framer from the tube without special tools? Some tube systems require a screwdriver to attach the focal frame.
• Is the screw that holds the framer to the tube long enough to hold the tube securely?
• Are framers available for use in air?

HOW TO USE EXTENSION TUBES

Although the exact details vary slightly with different manufacturer's extension tubes, and with your needs, the basic steps for using extension tubes are as follows:

Above water:
1. Lubricate the O-ring of a new tube, and the sealing surfaces on the camera body (Chapter II).
2. Attach the lens to the tube.
3. Attach the focal framer to the extension tube.
4. Attach the extension tube to the camera body.
5. Preset the aperture (pages 127, 128).
6. Preset the focus for minimum distance.

Underwater:
7. Frame your subject. (pages 121, 122).
8. Hold the strobe at the correct distance (pages 127, 128).
9. Take the picture.

CHOOSING FILM

ISO 50 or 64 film is a good film to start with. ISO 25 may produce sharper pictures, especially for making enlargements, but requires a more powerful strobe. ISO 100 will produce acceptable pictures, and can be used with low-power strobes.

DEPTH OF FIELD IS LIMITED

Depth of field is extremely shallow with extension tube close-ups. With the Nikonos lens set for f22, total depth of field is about 3/4-inch with a 1:3 tube, 3/8 inch with a 1:2 tube and 3/16-inch with a 1:1 tube. At f16, depth of will be reduced to about 1/2, 1/4 and 1/8-inch, respectively.

HOW TO AIM WITH THE FRAMER

For an entire close-up subject to be in sharp focus, it must be flat and flush with the framer. Generally the focused distance—the area that is sharpest—is flush with the outside of the framer. About one-half of the close-up depth of field will be in front of the focused distance, and one-half will be behind. (Note: This differs from normal depth of field, where one-third is in front and two-thirds behind.)

The most difficult part of extension tube photography is deciding where you want the plane of focus when photographing subjects that aren't flat. You must choose the main point of interest and place the framer so that the area you want sharp is at the exact focused distance. *As picture area gets smaller, placement of the framer becomes more critical.*

For example, if the subject has an eye visible in the picture, the eye usually must be sharply focused. Less important parts of the subject can be blurry. With plume worms, you want the front and the sides of the plume sharp, with flamingo tongues, you want the spots sharp. Each subject is different.

There will be space between the framer and the borders of the picture area. For accurate aiming, you must determine exactly where the picture area borders are in relation to the framer, and make marks on the framer as described on pages 123 and 124.

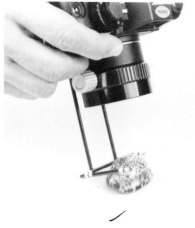

LEFT: The framer must be placed so the subject area you want to be sharply focused is flush with the outer part of the framer. BELOW LEFT: The subject is too far away from the framer for sharp focus. BELOW RIGHT: The subject is too close to the lens for sharp focus.

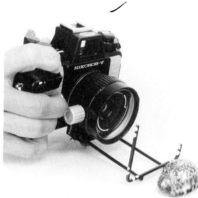

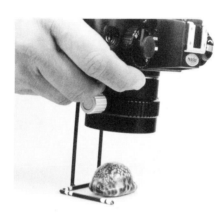

• Hold steady as your trigger the shutter. Some photographers get excited when they get close to a pretty creature. As they shoot, they seem to mentally yell "Gotcha!" and they jerk the camera forward as they fire the trigger. It is as though they are trying to grab the creature with their hand, when in reality it was already in the framer. Instead of holding steady and getting a good shot, they scare or even destroy their subject with the sudden movement.

• If the bottom of your extension tube gets in the way, turn the camera upside down. Maintain your grip on the camera and shutter release lever while twisting your wrist. (This is easiest with the old Model III.) If you need to have it upside down for the entire dive, for photographing plume worms, for example, try putting the tube on the camera upside down. Make sure that you angle the strobe light in from the front or side, and below the camera, to avoid having shadows of the frame support fall across the picture.

• Many photographers can't resist trying to photograph tiny creatures down in a hole. They reset the focus for infinity, but this will only extend the focus a few millimeters. When desperate, they will even remove the framer. While you can get lucky doing this, it rarely works well. In addition to inaccurate framing and focus, the strobe usually overexposes the foreground around the creature, and the creature is often in the shadow of his hole. But if it is a truly unusual opportunity, try it anyway—we still do. It only costs a few frames of film.

HOW TO CHECK YOUR FRAMER

If you aren't certain (a) where the picture area is within your framer, or (b) where the focused distance is in relation to the framer, you need to check your framer.

Here are three methods of checking framers:

1. Obtain a defunct Nikonos camera body. Cut a window in its back and cement a piece of glass over it. Remove the film pressure plate and cement a piece of ground glass over it. Then, you can:

a. Attach an extension tube and lens to the camera body.

b. Set the aperture for the widest opening and focus for minimum distance.

c. Submerge the front of the camera in a pan of water.

d. Place the framer over a test target.

e. Look through the window in the camera back and view the test target. A loupe is helpful, and use a small dive light to illuminate the target.

f. If the framer is adjustable for distance, adjust it for the sharpest focus.

g. If the framer isn't adjustable for distance, operate the focus control to see what distance setting give the greatest sharpness.

h. You can stack coins on the target surface to see if the sharpest focus is on the camera side of the framer.

i. You can raise the camera slightly to see if the sharpest focus is beyond the framer.

2. You can purchase (from Aquacraft II, at this writing) a lens focuser that can be used in place of our *see-through Nikonos* (above). If so, replace the plastic viewing screen with ground glass, and be careful not to drop the lens into the test tank as you use the lens focuser.

3. Make test photographs of a test target. You can make a target, or can use dive tables. Make sure to note exactly where you placed the framer on the target, so you can determine the exact edges of the picture area while you study the film.

Make small marks on the framer to show where the picture area starts. Use waterproof paint such as the rubber paint for marking SCUBA gear, or typing correction fluid.

At presstime, we learned that Aquacraft discontinued the Lens Focuser. However, some shops may still have focusers in stock.

RIGHT: The Lens Focuser available from Aquacraft II for checking extension tube framers. It attaches to the rear of the Nikonos lens. LOWER RIGHT: You submerge the extension tube and front of the lens in water and look through the lens at a target. BELOW: The authors' *see-through* Nikonos which is easier to use than the lens focuser.

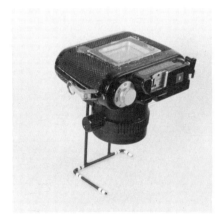

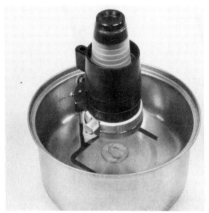

WHICH SIZE IS EASIEST TO USE

The larger sizes are easier to use because it is easier to see what is in the framer, and depth of field is greater. However, if the most photogenic creatures on the reef are only one or two inches long, you must choose a smaller tube such as the 1:2. In the Caribbean, where plume worms and flamingo tongues are common, we recommend that you master extension tube photography in the following sequence: 1:2, 1:3, 1:1, and finally, if you must have photos of particular tiny critters, 2:1.

As the extension tube gets longer, the focused distance gets shorter and the picture area gets smaller. And the smaller the picture area, the harder it is to use the tube. Imagine trying to hold the framer within 1/16 inch of a tiny critter—this takes good body control.

FACING PAGE: Fantail filefish taken in Hawaii with a 28mm 1:2 extension tube. Nikonos V set for A (auto) and f16; SB-103 set for TTL, and held approximately six inches from subject. Professional Kodachrome 64.

These illustrations show the picture areas for 1:1, 1:2 and 1:3 extension tubes. The bottom (1:3) picture of a blackbar soldierfish, lured into the framer with food, was taken in Grand Cayman with 28mm 1:3 extension tube. (Note the large female parasitic isopod on the fish's forehead, and the two smaller male isopods under the eye.) The 1:1 and 1:2 illustrations were cropped to simulate these reproduction ratios. Nikonos III, Ikelite Substrobe M and Kodachrome 25

HOW TO USE TTL

TTL is easy to use underwater with extension tubes. Just follow these steps:

1. Set the shutter speed for A (auto).
2. Set the aperture for f22 (f16 for the 2:1 tube).
3. Start with a strobe-to-subject distance of about six inches.
4. If you get a full-power flash signal, move the strobe in closer.
5. If you don't get a full-power flash signal, increase the strobe-to-subject distance until you do.
6. Once you find the distance at which the strobe signals a full power flash, move the strobe in an inch closer. This is the optimum strobe-to-subject distance for this particular combination of strobe, film speed, extension tube and aperture.

• If your TTL strobe doesn't have a full-power flash signal, use the TTL mode with the strobe distances given in the manual exposure section that follows.

HOW TO BRACKET TTL EXPOSURES

You may wish to bracket your TTL exposures to adjust for differences in subject reflectiveness and brightness. (See page 114.) You do this by changing the ISO film speed dial setting. For more exposure, use a lower setting. For less exposure, use a higher setting. The amount of exposure change required will be something you learn from experience. Each mark between the film speed numbers on the dial equals one-third of an f-stop.

HOW TO USE MANUAL CONTROL

Manual exposure is easy once you know what strobe distance to use. Just follow these steps:

1. Set the shutter speed dial for 1/60 second or M90.
2. Preset the aperture for f22 (f16 with a 2:1 tube).
3. Hold the strobe at the correct distance.
4. Take the picture.

To estimate strobe-to-subject distance, begin by looking at your manual exposure table and see what f-stop you would use for three apparent feet for the same ISO film speed chosen for use with the extension tube. (If you work with guide numbers, divide the U/W guide number by three to find the f-stop.) Then, use the information listed below.

For an f5.6 strobe at three apparent feet:
2:1 tube - 3 to 6 measured inches (f16).

1:1 tube - 3 to 6 measured inches (f22).
1:2 tube - 4 to 8 measured inches (f22).
1:3 tube - 5 to 9 measured inches (f22).
With the 1:2 tube, for example, the range is four to eight inches. Four inches is for dark subjects; eight inches is for light subjects. For average subjects, use the middle of the range—six inches for this example.

For an f8 strobe at three apparent feet:
2:1 tube - 4 to 8 measured inches (f16).
1:1 tube - 4 to 8 measured inches (f22).
1:2 tube - 6 to 12 measured inches (f22).
1:3 tube - 7 to 13 measured inches (f22).

For an f11 strobe at three apparent feet:
2:1 tube - 4 to 8 measured inches (f22).
1:1 tube - 6 to 12 measured inches (f22).
1:2 tube - 8 to 16 measured inches (f22).
1:3 tube - 10 to 20 measured inches (f22).

Once you have standardized with a specific strobe and film, you will notice a convenient consistency. As the reproduction ratio gets smaller, the strobe must be held closer to the subject. However, the extension tube framer is also shorter. Thus, if you usually hold your strobe with the edge of the reflector near a particular camera part—such as the rewind knob—this relation tends to remain the same for any of the extension tubes.

TESTING FOR MANUAL EXPOSURES

If the strobe-to-subject distances in the preceding section don't work for you, here is how to test for your own strobe distances:
1. Load with the film of your choice (ISO 50 or 64 would be good) and preset the lens for f22 (f16 for a 2:1 tube).
2. Take a series of underwater pictures of light, average, and dark subjects, with strobe-to-subject distances from about two inches to one foot. Use camera parts as reference for distance, such as the front of the lens, control knobs, rewind knob, etc. Be methodical and remember the sequence of distances used.
3. Project your slides and determine which distances were best for your different subjects. Be sure to write down your results.

HOW TO BRACKET MANUAL EXPOSURES

The best way to bracket is to vary the strobe distance. If, for example, you judge a subject to be average to bright, make two exposures. Hold the strobe at the middle of the range for one, and at the far end of the range for

UPPER LEFT: Cupcorals; TTL exposure bracketed to ISO 64 for Pro. Fujichrome 50; 28mm 1:3 tube. LOWER LEFT: Filefish; normal TTL exposure with twin strobes; 35mm 1:1 tube; Pro. Ektachrome 64. BELOW: Hermit crab; manual exposure; 28mm 1:2 tube; Kodachrome 64. BOTTOM: Seahorse; manual exposure with two strobes; 35mm 1:1 tube; Kodachrome 25.

the other. If you judge a subject to be average to dark, make one exposure at the middle of the range, and one at the near range.

AIMING THE STROBE

If you handhold your strobe, and your exposures are inconsistent or are too dark overall, you may be misaiming your strobe. It is easy to misaim a narrow-beam strobe so almost no light reaches the subject. Look at your strobe and make sure it is aimed directly at the subject.

SOME TUBES CAUSE FLARE

The inside of the barrel of an extension tube is rough and black. This is to prevent light from reflecting and causing a flare spot in your picture. For several years the extension tubes made for AQUA CRAFT, INC had very fine, shiny grooves that did not adequately prevent flare. Look at your pictures taken with 1:2 and 1:1 tubes. Look near the center, or lower center of a picture that has an average or dark subject. If there is a light, flared spot, then the tube is defective.

To eliminate flare, you can spraypaint the inside of the tube with matte black paint. Or you can line the tube with black flocking material. You can order pressure sensitive black flocked paper from Edmund Scientific Co., 101 E. Gloucester Pike, Barrington, NJ 08007.

FOR MORE USEFUL TIPS

Turn to the chapter, HOW TO USE CLOSE-UP LENSES, and read the following sections:
• Strobes for close-ups, page 97.
• Using TTL for close-ups, page 111.
• Bracketing TTL exposures, page 113.
• Fine-tuning Manual exposures, page 116.

Chapter XI

How To Use
Multiple Strobes

After you are comfortable with one strobe (and have read the single strobe sections that apply to you) you may be ready to enjoy the infinite variety of lighting techniques that require more than one strobe.

This chapter will concentrate on the mechanics of determining exposure when using more than one strobe with your Nikonos IV-A and V. For information on backlighting, color panels and other advanced and creative lighting techniques, see our companion text, *Choosing and Using U/W Strobes*.

ADDING A SECOND STROBE

At least one strobe will be triggered via the connector cord (sync cord) that connects the strobe to the camera. The other strobe will be triggered by either a dual sync cord or a slave sensor:

• A dual sync cord can be used to connect two strobes to the single flash socket of a Nikonos camera. When the camera shutter is released, both strobes will be triggered. This provides reliable firing of both strobes regardless of strobe aim or sunlight.

• A slave sensor can be built into a strobe (called the *slave strobe*), usually near the reflector. This sensor triggers the strobe to flash when the slave sensor detects the flash of light from another strobe (called the *master strobe*). A master strobe can trigger one or several slave strobes.

• The light from the master strobe must strike the sensor with brighter light than the sunlight or else the sensor will not detect the flash, and the slave will not fire. Thus, care must be taken to prevent sunlight from overpowering the master strobe.

RIGHT: Cathy poses with slave strobe at Hawaii. Nikonos IV-A set for f8 and M90; Subsea Mark 100 at 100 watt-seconds. Professional Ektachrome 64.

BELOW: Kathie Mullins poses with slave strobe off Virgin Gorda, B.V.I. Nikonos V set for f8, A (auto) and ISO 200 for Professional Fujichrome 100.

LEFT: Engine room telegraph on the bridge of the *Fujikawa Maru*, Truk Lagoon. Three strobe lighting with manual exposure control. One strobe angled down from the upper left, one from directly above and one directly from the right. Professional Ektachrome 64.

BELOW: Cathy poses at the midsection of the *RMS Rhone*, B.V.I. Her slave strobe is set for 1/16 power and two layers of white cloth have been placed under the wide-flash adaptor. Normal TTL exposure for Professional Fujichrome 50.

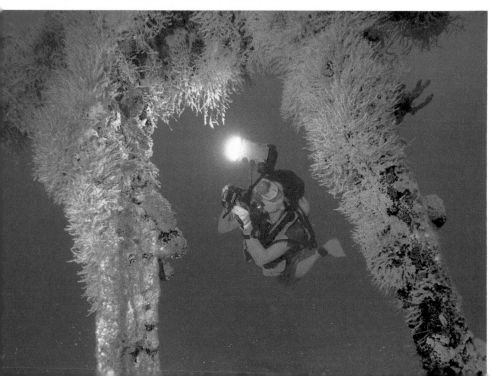

HOW TO USE TWO MANUAL STROBES

Let's start with a simple combination, two strobes and manual exposure control. Even if you plan to use TTL strobes, reading this section will help you understand how subjects are exposed with two strobes.

In the following examples, the f-stop shown on each strobe indicates the aperture you would use if you were using that strobe alone. The f-stop shown on the subject is the f-stop that you would set on the camera lens.

• For now, think only of the two strobes—we'll discuss the sunlight exposure later.

• The fish in the following diagrams only represents an average subject— don't attune your mind to just fish photography.

Figure 1: Two equally powerful strobes are both lighting the same subject area equally. Set the aperture one stop smaller (higher f-number) than you would for one strobe. In the example below—with two f8 strobes—set the aperture for f11.

Figure 2: Two strobes are lighting the same subject area, and one strobe is a stop stronger than the other. Determine the aperture for the strongest strobe, then close by a half stop (higher f-number). Note: It doesn't matter why the second strobe is weaker. It could be smaller, held further away or have a diffuser over the reflector—the effect is the same.

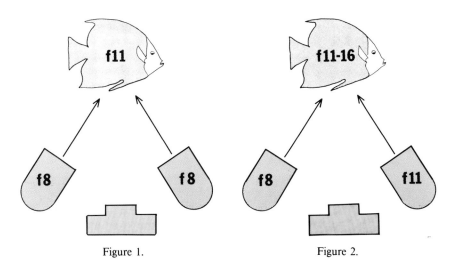

Figure 1. Figure 2.

Figure 3: Two equally powerful strobes are lighting different sides of the subject. Because there is little overlap of strobe light, set the aperture for f8—the aperture you would use with only one strobe.

Figure 4: Two strobes are lighting different sides of the subject, and one strobe is stronger than the other. Set the aperture for the strongest strobe. The weaker strobe will provide fill lighting on the shadow side of the subject.

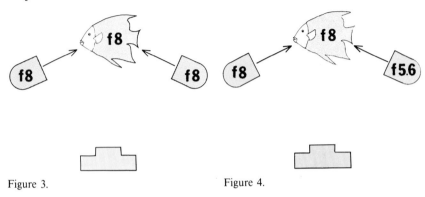

Figure 3. Figure 4.

Figure 5: If two equally powerful strobes are angled so their beams intersect behind the subject, set the aperture for the aperture you would use with one strobe (f8 in this example). If one strobe were stronger than the other, set the aperture for the strongest strobe. Note: This technique minimizes the number of illuminated particles between the camera lens and the subject.

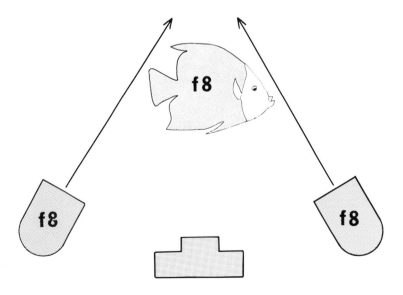

WHAT IS THE EFFECT OF SUNLIGHT?

Regardless of what combination of strobes you use, you must consider the sunlight exposure. Assuming that direct sunlight strikes the subject from a different angle than the strobe light, proceed as follows:
 • If the sunlight is brighter than the strobe light, set the aperture for the sunlight exposure. This often happens when you take pictures at distances of about three feet or more in bright water.
 • If the strobe light is brighter than the sunlight, set the aperture for the strobe exposure. This is what usually happens when you take close-ups.

If both sunlight and strobe light strike the same subject area from about the same angle, you must compensate by closing the aperture.

Figure 6: Two equally powerful strobes and sunlight are lighting the same picture area from about the same angles. The two f8 strobe exposures equal an f11 exposure. Add the combined f11 strobe exposure to the f11 sunlight exposure, and you get f16.

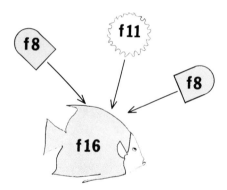

Figure 7: Two equally powerful strobes and sunlight are all lighting from different angles (other than backlighting). The strongest light source—the f11 sunlight—determines the exposure.

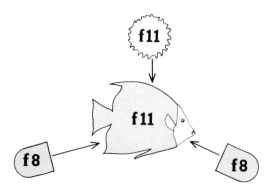

TESTING YOUR UNDERSTANDING

PROBLEM: You are taking a diver portrait at three apparent feet with two strobe lighting and manual exposure control. Your main strobe, set for full power and angled in from your left, is high-lighting the diver's face and chest. Your fill strobe, set for 1/4 power and angled in from your right side, is filling in the shadow side of the diver.

Your exposure meter reads f5.6 for the midwater background, your exposure table indicates f8 for the main strobe and f4 for the fill strobe. What aperture should you use?

SOLUTION: The strongest light source, the f8 strobe, determines the basic exposure. Although the f4 wide-angle strobe and sunlight both contribute light, these light sources aren't striking the subject from the same angle, so they have less effect. We would expose at f8, and then bracket to f8 plus one-third stop if the diver has light skin.

OPTIONAL—COMBINED GUIDE NUMBERS

If you prefer to work with guide numbers, the formula for determining the combined guide number (GN) of two or more strobes (GNx) lighting the same subject area, is as follows:

$$\text{Combined GN} = \sqrt{GN1^2 + GN2^2 \ldots + GNx^2}$$

OPTIONAL
TESTING YOUR UNDERSTANDING

PROBLEM: You wish to use two flash units to light the same subject area, at the same strobe-to-subject distance. The U/W GN of one strobe is 16, the other is 22 (for the film speed used). What is the combined U/W GN of these two strobes?

SOLUTION: The combined U/W GN is 27.2.

USING TWO TTL STROBES

Two TTL strobes, connected by a dual sync cord, can be used for two-strobe lighting.

•For now, we will ignore sunlight and think only of the two TTL strobes. Once you have a combined TTL aperture for two strobes, read the sections on using strobe with sunlight on pages 56 to 59, and 43 and 137.

Figure 8: Although both strobes light the same subject area equally, and you are within the automatic range, you need not make an exposure compensation. The TTL will automatically shut off both strobes.

Because the two equally powerful strobes can deliver twice as much light as one strobe, you can use this extra light to increase the automatic range, or to use a higher-numbered f-stop to increase depth of field.

Look at the SB-103 exposure table for ISO 100 on page 41. The estimated automatic range for an f8 exposure with one strobe is three feet. With two strobes, the automatic range would be increased to four apparent feet because one f-stop more light is available.

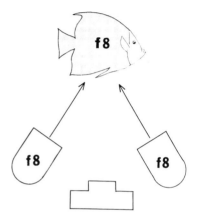

Figure 9: If one TTL strobe is more powerful than the other, base aperture and automatic range on the most powerful strobe. The weaker TTL strobe will provide fill lighting only.

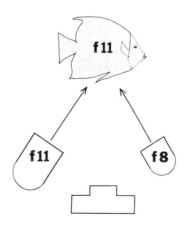

Figure 10: If you wish to use one TTL strobe for your main light source, and another equally powerful TTL for fill lighting, the light output of the fill strobe can be reduced by placing a wide-flash adaptor (or other diffuser) over the reflector of the fill strobe. A single layer of white bed sheet will reduce output by about one stop.

Figure 11: If you don't have a wide-flash adaptor or other diffuser, increase the strobe-to-subject distance of the fill strobe by about 50 percent to reduce its intensity by about one f-stop.

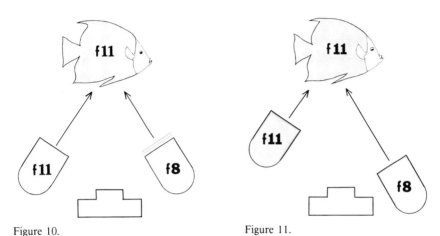

Figure 10. Figure 11.

CLOSE-UP TTL AUTOMATIC RANGE

If you aim two equally powerful TTL strobes at the same close-up or extension tube picture area, twice as much light is available for the exposure. Therefore, close the aperture by one stop (next higher-numbered stop). If, for example, your TTL aperture is f16 with a single strobe, and a strobe-to-subject distance of one measured foot, set the aperture for f22 when using two strobes.

If, however, you already use f22 with one strobe, adding the second strobe could increase the minimum automatic range to more than twelve inches—your strobes could be too close to shut off in time to prevent accidental overexposure. You can compensate by:

• Using a wide-flash adaptor or diffuser to reduce light output of one strobe.
• Increasing strobe-to-subject distance of one or both strobes by at least 50 percent.
• Changing to film with about half the ISO film speed.

MIXING TTL AND MANUAL EXPOSURE CONTROL

Even though you have a TTL strobe, you or your buddy may have a manual strobe that you wish to use for two-strobe lighting. If so, you can mix TTL and manual strobes for two-strobe lighting. Keep in mind that while the TTL strobe shuts off when enough strobe light reaches the subject for the exposure, the manual strobe flash continues for its full duration. Therefore, you must consider the additional exposure that may be provided by the longer flash duration.

In our examples, we will assume that the TTL strobe is the main light source, and that the manual strobe is the secondary or fill light.

Figure 12: If both strobes illuminate the same subject area, set the ISO dial one mark past the actual film speed used, to reduce the TTL exposure by 1/3 stop. (This will be your normal TTL exposure. If you decide to bracket, bracket from this setting.)

Then, make sure that the manual strobe illuminates the subject with at least two stops less light intensity than the TTL strobe. To reduce the light intensity of the manual strobe, you can use a lower power setting, or place a diffuser or cloth over the reflector. Doubling the strobe-to-subject distance reduces light intensity by about two stops. (This amount can vary with distance and reflector design.)

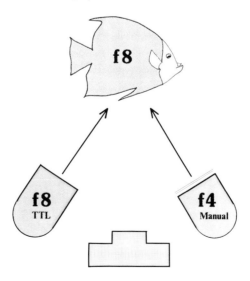

Figure 13: If both strobes illuminate different subject areas, the manual strobe should be about one stop weaker than the aperture set for the TTL strobe. This produces fill lighting for the shadow side of the subject. Increasing the strobe-to-subject distance by 50% reduces light intensity by about one stop. (This percent can vary with distance and reflector design.)

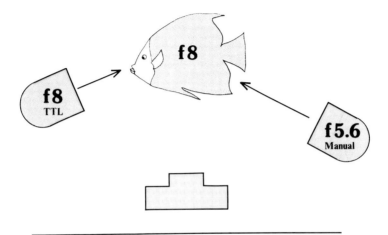

TESTING YOUR UNDERSTANDING

PROBLEM: You are taking a diver portrait at two apparent feet with your 28mm lens. Your twin TTL strobes are bracketed on arms at the left and right sides of your camera. Your main strobe is your left; your fill strobe is on your right.

You wish to expose at an aperture that will darken the f5.6 sunlight exposure by two stops, and to have fill strobe lighting that is two stops weaker than the main strobe lighting. Using the exposure table on page 41 for reference, what should you do?

SOLUTION: (1) Set the aperture for f11—this will darken the f5.6 background by two stops. (2) Set the left strobe for TTL. (3) Set the right strobe for 1/4 power.

Your subject will be brightly illuminated by the left strobe, and will be illuminated on the top and right side by f5.6 sunlight and strobe fill. To prevent overexposure of light skin tones, bracket to less exposure by increasing the film speed dial setting.

Appendix A: Flooded Camera

This is a touchy subject! By repairing your own camera, you could not only void your warranty, but could also damage the camera by working on it without proper tools or training.

However, if you are on an expensive diving vacation, and the cost of the trip far exceeds the value of the camera, the chances of your being able to repair (at least temporarily) a flooded camera or lens may well be worth the potential risks. We believe that you have a reasonable chance of getting your camera back in action if you follow our procedures. And when the trip is over, send it to a repair person with detailed notes on what repairs you undertook.

> WARNING: We are not trained camera repair persons and can not guarantee the methods we use, nor are our procedures endorsed by Nikon. Also, because of design changes, the internal camera parts may not be exactly as described or shown.

SPECIAL TOOLS AND SUPPLIES

The minimum tools and supplies are:
1. A set of jeweler's screwdrivers, including a #0 Phillips.
2. An adjustable spanner wrench (or fine needlenose pliers) and flex-clamps.
3. A small hair dryer.
4. Fresh water. Water at resorts and live-aboard dive boats, although drinkable, is often brackish enough to damage camera parts. Keep a gallon of distilled water with you on long trips.
5. An icecube tray, egg box or other container where you can store parts sequentially.

• *Don't use WD-40 or alcohol on Nikonos IV-A or V camera parts. These can damage glues and circuits.*

6. Always use a tool that fits properly. If a screw resists, it may be corroded or glued in place. Set the screwdriver firmly into the screwhead and tap it sharply with another small tool. Use firm downward pressure when turning the screw. If you strip the head, all further progress is stopped. Briefly touching the screwhead with the tip of a soldering gun can loosen glue, but don't do this with screws that are near plastic.

FLOODED IV-A OR V BODY

We will assume a major flood. If you have a partial flood, use your own judgement to modify our procedures. When deciding whether to rinse camera parts with fresh water, remember that a cup of fresh water will do less damage than a drop of saltwater in the wrong place. We would proceed as follows:

The first steps:

1. Turn the shutter speed dial to M90 to turn off the camera electronics. If a strobe is attached, turn it off.

2. Remove the lens—set it with the rear lens facing down. If flooded, you will work on it later.

3. Remove the camera battery and leave the compartment open.

4. Try to rewind. If you feel resistance, film is wet and emulsion swollen. Don't rewind—open camera and throw film away.

5. With camera back open submerge the camera body in fresh water. If water supply is limited, close the back and pour water into the front of the camera. Work shutter several times at M90. Change the water at least three times.

• At this point, the camera will be safe as you get out of your wetsuit, dry yourself and get to a dry workspace.

Basic disassembly:

1. Lay the camera body face down with the back opened.

2. Remove the four screws that hold electronics cover plate.

3. Rinse the electronics compartment with fresh water—rotate the ISO and film speed dials while submerged or as water is poured into the compartment.

4. Hold the pressure plate up, and work the shutter release while submerged or as someone pours fresh water onto the curtain blades.

• **Decision point:** Depending on the situation, you can skip the next disassembly sections and proceed directly to the *finish the drying* section.

ABOVE: Remove the electronics cover plate, four screws. LEFT: Adjustable spanner wrench and lens Flexiclamps are used for repairing flooded lenses.

Removing the shutter speed assembly:

1. Set shutter speed for M90.

2. Pry rubber cap (V) or leatherette (IV-A) off shutter speed dial.

3. Remove the screw through the film advance lever. (With IV-A, use a spanner wrench or needlenose pliers. Don't push downward too hard.)

4. Grasp the shutter speed dial ring and lift it off.

NIKONOS IV-A
RIGHT: Remove retaining screw with needlenose pliers.

Remove the film advance lever. Remove the shutter speed dial.

NIKONOS V: Remove screw.

Raise shutter speed dial.

Remove second part of shutter speed dial.

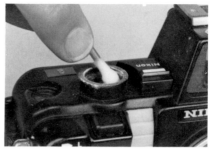

Clean and lubricate exposed O-rings, such as shown above on the V film advance shaft.

Clean all sealing surfaces, such as the top of the Nikonos V shown above.

Removing the ISO dial/rewind assembly:

1. Set the ISO dial for ISO 1600.

2. Remove the spring clip that holds the rewind shaft. Gently pry out, a little at a time, with a screwdriver tip. With a Nikonos V, be careful not to scratch the O-ring sealing surface. Keep your hand over the clip to prevent it from flying across the room as you release it.

3. Pull the film speed dial out of the camera. With IV-A, rotate rewind fork to release assembly. Note relative positions of parts.

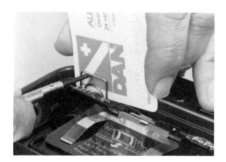

Remove spring clip.

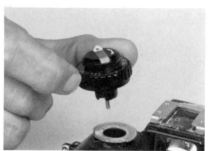

Pull out rewind assembly.

IV-A rewind assembly.

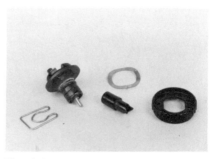

V rewind assembly.

Removing the inner camera body:

1. Lay the camera body face down.

2. Nikonos IV-A only: Remove the two screws that hold the sensor (just above the pressure plate hinge).

3. Remove three screws (one in film cassette section, two to the right of the film takeup spool).

4. Gently lift the inner body—bottom first—out of the outer casing. **Warning:** *The top of the inner body is connected to the top of the casing with wires. Don't tug on these!*

5. Holding the camera body and casing together to avoid pulling on the wires, rinse again in fresh water. Holding your hands together, carefully swing the camera and casing in a fast arc to drive out water.

6. Blow dry all exposed areas with low-pressure, warm (not hot) air from a hairdryer. *At no time should the camera parts get hot to the touch.* You will dry the shutter blades again after reassembly when you can work them while drying.

Loosen IV-A sensor plate screws.

Remove three screws in camera body.

Inner body pivots out of camera casing. Don't tug on wires at top. Battery compartment lid must be off.

REASSEMBLE THE CAMERA BODY

Inner body and casing:
1. Place inner body back—top first—inside the outer casing. Note: Make sure the shutter release lever (in upper right of the inner casing) is all the way up. If shutter will not trigger when assembled the lever may have been too low.
2. Replace the three screws that hold the inner body in place. Place a tiny dab of silicone grease on the end of the screwdriver point to hold the screws in place as you lower the screw and screwdriver into the camera body.
3. Nikonos IV-A: Replace the LED plate above film pressure plate. It fits under the film pressure plate spring.

ISO dial and shaft:
1. Clean and lubricate the ISO dial O-ring.
2. Reassemble the ISO dial assembly. Lower it all the way in place and replace the spring clip.
• The protrusion on the lower, inside of the ISO dial ring, should be just beyond the ISO 1600 marking.

Align ISO dial parts. The protrusion on the bottom of the ISO dial ring should be near the 1600 on the dial. Press the top of the rewind level downward with your fingers to compress the spring during reassembly.

Looking inside the camera body, you can watch as you align a notch on the ISO dial shaft with a tab in the camera body. With the IV-A, you may need to rotate the rewind fork (in the camera body) to seat the assembly. Lift the rewind crank so you can press on the ISO dial with your fingertips until the spring clip notch on the shaft is visible in the camera body. Insert the spring clip. Try to pull the assembly back out to verify that the spring clip is gripping. Reassembly may take several attempts—don't panic.

Shutter speed shaft and film advance lever:

1. Clean and lubricate the film advance shaft O-ring (attached to inner casing on IV-A, and to the film advance lever of the V).

2. Clean and lubricate the inner surface of the shutter speed dial O-ring seat (on top of camera body). Don't grease the outside parts as grease could hold sand.

3. Replace the shutter speed dial—set for M90. Rotate it counter clockwise. If replaced correctly, it will stop at the R (rewind) position, and the film sprocket spool should rotate freely. Turn the sprocket teeth with your finger to test it. Return to M90 and the sprocket should no longer rotate in both directions.

4. Replace the film advance lever. (With the V, the shaft is attached to the film advance lever. The end of the shaft fits into an internal slot inside the camera.

5. Replace the screw that holds the film advance lever in place.

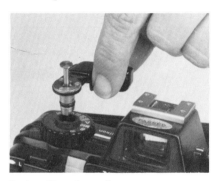

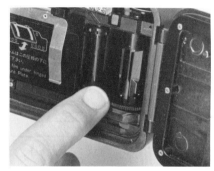

Replace film advance lever. Check sprocket movement.

FINISH THE DRYING

1. To dry the shutter curtain blade assembly, aim a hair dryer—low power and low heat—directly into the front of the camera. The objective is to gently force air through and between the shutter curtain blades.

2. Operate the shutter release. Continue to dry while the blades are in the charged (ready to fire) and released positions.

3. If the shutter sticks in one position, don't panic. This is a normal response to being only damp rather than completely wet. If stuck slightly up, push the blades straight down into the camera body (or thump the bottom of the camera body against your palm) to release the blades. Continue drying without further operating the shutter.

4. Place the camera body inside a cardboard drying box. Direct a hairdryer—low power, low heat—into the box to set up a flow of warm, dry air. Dry for a half hour and try to trigger the shutter again. If the blades stick, continue drying. When completely dry, they will work freely.

• If you skipped over the disassembly sections, dry the camera for several hours. An old-fashioned gas oven—with just the pilot light burning—is great for an overnight drying.

• With the Nikonos IV-A, tuck lens cleaning tissue into the narrow space between the bottom of the inner body and casing to pull water out. Do this until the tissue comes out dry.

• **Do not test with batteries** until it is thoroughly dry. Depending on your drying conditions you may want to wait until overnight.

FLOODED 35mm & 28mm LENSES

A minor flood can occur if water from inside the camera body seeps past the spring-loaded rear lens mount. This water often shows up as droplets or fog on the inside of the lens port. The basic repair is to simply remove the inner lens barrel, dry the lens and mount, and put it together again.

The steps are as follows:

1. Set the control knobs for infinity and maximum aperture. Lay the lens face down and remove the four spring-loaded screws (page 8). Be careful—these screws can fly out if your screwdriver slips.

2. Lift the inner lens mount out of the outer lens housing and set it down on a clean working surface.

3. Locate the parts on the inner lens mount that must be aligned with the outer lens housing: A wide slot for the focus control and a narrow slot for the aperture control must be aligned with a guidepin hole (A) at the far side of the

RIGHT: Lift inner lens mount out. Locate parts that must be aligned. LOWER LEFT: Slots for focus and aperture controls align with guidepin hole (A) and alignment notch (B). LOWER RIGHT: Guide pin (C) aligns with focus control tab and aperture control screwhead when set for infinity and wide-open. Metal tab (D) fits into groove (B).

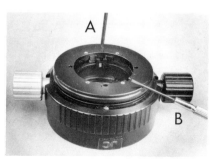

mount. Also, most lenses have a machined notch (B) at the "4:30 O-clock" positon, relative to the slots.

4. Locate the parts which must be in alignment on the inner lens mount; A wide tab for the focus control, and a narrow screwhead for the aperture control, must be aligned with a guidepin (C). Note: The tab, screwhead and guidepin (C) of the inner lens mount fit into the wide slot, narrow slot and guidepin hole (A) of the outer lens mount. And with most lenses, the inner mount will have a metal tab (D) or screwhead which fits into the machined notch (B) of the outer lens mount.

5. Use warm water to flush the outer lens mount through the opening at the rear. Blow dry with a hairdryer (low power, low heat). Use lens tissue (or soft cloth) to clean the inside of the lens port.

6. Assuming that water didn't penetrate past the exposed glass elements of the inner lens mount, wipe the exterior of the lens mount with a soft cloth and clean the glass elements (pages 9-10).

7. To reassemble, carefully align the parts described in steps #3 and #4, and carefully lower the inner lens mount into place. You may need to use a small screwdriver move tab (D) for perfect alignment.

WATER PAST THE ELEMENTS

If water seeped past the lens elements, the first-aid treatment is more complicated.

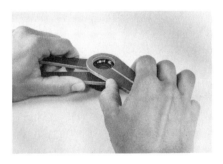
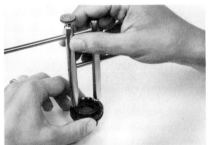

ABOVE: Use lens wrenches to remove front retaining ring and free the front lens element. UPPER RIGHT: Use an adjustable spanner to unscrew slotted retaining rings. RIGHT: A field-stripped 35mm inner lens mount. When reassembling, the lenses curve outward. Avoid rotating other inner lens mount parts so proper focus will be maintained.

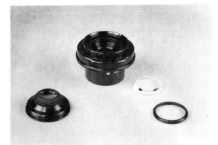

The front element of a 28mm lens (and some old 35mm lenses) is held in place by a threaded retaining. This ring has two slots (which you can see through the lens port), so it can be unscrewed with a spanner wrench. You can use a jeweler's screwdriver in one slot, but be careful that it doesn't slip and scratch the lens.

The retaining ring that holds the front element of 35mm lens in place doesn't have the slots (see 28mm lens, above). Use a pair of Flexiclamp wrenches to unscrew it.

The iris diaphragm blades of the aperture control will be exposed when you remove the front lens element. If wet, rinse with fresh water and blow dry with the hairdryer. Clean the lens element with lens cleaner and tissue.

The rear lens element may be held in place with a retaining ring, or may be in mounting. Either way, locate the pair of innermost slots at the rear of the inner lens mount and unscrew them with a spanner as you hold the inner lens mount to keep it from rotating. With both elements, reverse the procedure to reassemble.

• Warning: You may have upset the focus. To check focus:

1. Attach the lens to the camera, and set it for the widest aperture and three feet.

2. Set for B (bulb) and raise the pressure plate.

3. Aim the camera at a contrasty subject (such as a set of partially open venetian blinds), hold a piece of waxed paper over the film plane.

4. Look at the waxed paper. If you see a sharp image, the lens is close to the proper focus.

FLOODED 15mm LENS

From the moment you detect a flooded lens, hold the lens dome down, so the water collects in the dome port. Field strip as follows, noting photos on following page:

1. Set the controls for infinity and f2.8.

2. Remove the six spring-loaded screws at the rear.

• If you feel resistance, hold the screwdriver snugly in place and tap the screwdriver sharply with a small tool. Don't use excessive force to turn the screw or it will break above the threaded portion.

• If you still feel resistance, drip a penetrating lubricant (such as Teflon) onto the screwheads with tweezers or a screwdriver tip. Don't spray the lubricant near the lens! You might proceed to step #3 as you wait for the lubricant to penetrate.

3. Remove the six screws that hold the lens hood in place. If necessary, tap and use lubricant (as above.)

• Do not proceed to step #4 until you have done both steps #2 and #3.

4. Lift the lens body off the lens hood and dome.

5. Remove the circular plastic window. It will probably fall out as you lift it,

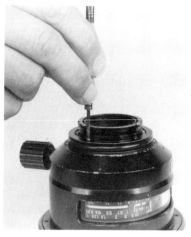

Remove four screws.

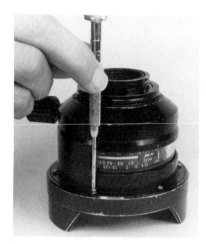

Remove six screws.

unless your fingers are gripping it on the side.

• Don't set the lens body face down because the front lens element protrudes. For the next three steps, continue to hold the lens body in your hand, with a finger across the rear of the lens mount.

6. Use finger and thumb to unscrew the front lens element—it takes several turns. If it doesn't come out, use a spanner in the two holes. Don't touch the glass.

7. Lay the element down, face up.

8. If the plastic window rear O-ring didn't fall out with the window, rap the lens body against the palm of your hand to knock it out.

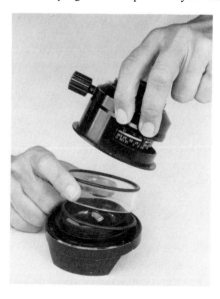

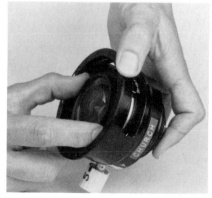

LEFT: Lift lens body off lens hood and dome. ABOVE: Unscrew front lens element. Lay it down face up.

9. Lift the inner lens mount out from the outer lens casing. If it doesn't lift, wiggle the control knobs slightly as you gently rock the barrel. Set the barrel down on it's back because the front element protrudes outward.

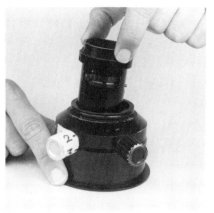

Lift inner lens body.

Note position of alignment tabs.

10. Wash the front port, window, window O-rings and lens casing with fresh water—don't use alcohol. If the lens barrel isn't flooded, simply wipe it's outer surface. Lens coatings are fragile, be extremely gentle.

11. Clean and dry the parts; don't grease the window O-rings. Reassembly is just the reverse of disassembly.

• When replacing the lens barrel, it is easy to determine which notch in the lens casing aligns with the aperture screwhead on the barrel. Turn the aperture knob on the lens casing to see which one moves.

• When replacing the lens hood, be sure that the protruding shades of the lens hood align with the bayonet mount flanges at the rear of lens. Set the screws in place and tighten them alternately on opposite sides. Press down on the body during the final tightening as the screw tension determines the O-ring seal.

•If water has penetrated the inner lens mount, repair is beyond our first-aid procedure. If you have good tools, and you are really desperate, you might remove the next front element on the inner lens mount. Use a tool that will reach the two holes in the retaining ring. This will expose the aperture blades for a thorough rinsing. Removing the rear retaining rings will upset the focus. Reassemble the lens and send it to a repair shop.

FLOODED OLD-STYLE 15mm LENS

Use the 35 and 28mm procedure on pages 150 - 151, except for alignment of the inner lens mount and the outer lens casings. Two notches in the casing align with the black aperture tab and a white tab on the inner lens mount. The notch for the focus control aligns with a black tab on the inner lens mount. Three guidepins on the inner lens mount also align with three slots in the casing.

Appendix B: Nikon Strobes

NIKON SUBMERSIBLE STROBES

	SB-101	SB-102	SB-103
Exposure control:	A/M	T/M/A	T/M
Manual Settings:	F, 1/4	F, 1/4, 1/16	F, 1/4, 1/16
Slave mode:	no	yes	no
Battery:	8 AA, n or a	6 C, n or a	4 AA, n or a
Number of flashes (full):	150a	70n, 120a	50n, 130a
Recycle time (seconds):	5 or more	5n, 14+a	6n, 9+a
Beam angle:	35mm	28mm	28mm
Wide-flash adaptor:	28mm	15mm	15mm
ISO 100 guide members (air):	106/53	106/53/26	66/33/16
User-detachable cord:	no	yes	yes
Dual sync cord:	no	yes	yes
Target light:	no	yes	no
Approx. dimensions (in.):	3.75 x 6.25	5.5 x 8.25	3.75 x 6/3/4

ABBREVIATIONS:
T = TTL exposure control.
A = Automatic with remote SU-101 sensor.
M = manual exposure control.

F = full power
a = alkaline
n = nicad

NIKONOS SPEEDLIGHT SB-101

The SB-101 (see photo on page 52) was Nikon's first U/W strobe. Introduced in 1980 for use with the Nikonos III and IV-A, the SB-101 replaced the earlier Nikon BC (battery-capacitor) flashbulb units.

When the wide-angle adaptor was used, the light output of the SB-101 was reduced by approximately one f-stop. The quality of the light, however, was improved because light rays within the beam were diffused which reduced glare, and the "hot spot" in the center of the beam was virtually eliminated.

• When inserting the eight AA cells into the battery pack, double check that all cells are facing the correct direction. If one alkaline cell is in backwards, the SB-101 will recycle at first, then the battery pack voltage will fall quickly and fail to recycle the strobe. This usually happens when you are underwater and have taken only a few exposures with your fresh batteries.

• When opening the battery compartment, aim the handle downward as water can be trapped inside the lid and run inside the battery compartent.
• Even if you don't use the sensor unit, frequently clean and lubricate the threads of the sensor port cap.
• Don't put the strobe down with the flash head aimed upward. The cords at the rear will be unduly bent and flexed. Bending and flexing eventually breaks these fragile cords.
• Use 1/4 power manual exposure control as much as possible. This extends battery life, reduces recycle time and reduces backscatter fom suspended particles.

NIKONOS SPEEDLIGHT SB-102

• A mechanical calculator dial at the rear of the SB-102 can be used to determine f-stops for manual and TTL exposures, and the minimum and maximum automatic range (coupling distance) for TTL. It also gives the automatic stops and automatic range for the SU-101 remote sensor.

The SB-102 doesn't do well with disposable alkaline or general-purpose batteries. Alkalines can't always provide enough energy for a full-power flash, so a full-power flash may be less than Nikon specifies even though the ready light is on (at 80% of a full charge). Recycle time lengthens as batteries weaken. General-purpose batteries simply don't have the strength to power the SB-102. If you must use disposable batteries, use alkalines.

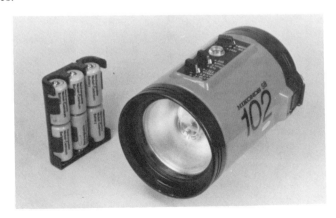

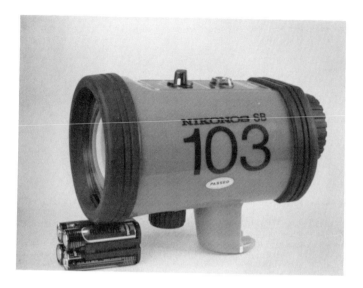

We place the strobes on the outsides of the strobe arms to increase the distance between the strobes. The disadvantage of this method is that you can't see the ready lights and switches.

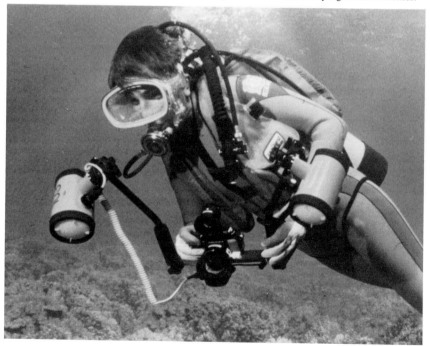

• Be sure that all of your C cells are loaded correctly in the battery pack. If one cell is reversed, and you have the old-style battery carridge, the strobe electronics can be severely damaged. At this writing, Nikon has introduced a modified C-type battery cartridge that interrupts the circuit if a cell in installed incorrectly.

• Don't mix old and new nicads, or nicads that have been charged for different times. Label sets of cells and charge and use them as sets.

• Purchase a second battery cartridge and a second set of nicad cells. It is easier to change cartridges on a dive boat than to change the individual cells.

• Handle the locking latches carefully—they can be damaged if you're heavy handed.

• Don't forget to clean and lubricate the threads of the sensor port cap, even though you may not use this feature.

• Use a safety cord to prevent loss of the wide-flash adaptor.

• The aiming light is difficult to use in bright light, or on small moving subjects. Learn the aim the strobe by feel, or attach a larger light such as a Q-Lite, to the strobe.

• The strobe head tends to float upward from the front, causing fatigue with prolonged use underwater. Tape a few ounces of lead under the front to balance it.

NIKONOS SPEEDLIGHT SB-103

The SB-103 is a compact TTL strobe that shares the same connector cord, and arm and bracketing system as the SB-102.

• An exposure decal is provided for determining manual and automatic exposures, and automatic range (coupling distance).

The SB-103's advantages are its compact size, modest battery requirements and its versatility for both close-up and wide-angle photography. As for disadvantages, it doesn't have the slave mode and target light of the larger SB-102, and is about one f-stop weaker in light output than the SB-102.

• Purchase an extra battery cartridge for a second set of cells. It will be easier to change cartridges on a dive boat than to try to replace individual nicad cells. Note: It is the same MS-5 cartridge used with the Nikon Speed Light SB-16.

• The SB-103 battery compartment lid traps water. Hold the battery compartment lid downward when removing it. Then, shake the lid to remove trapped water.

Charge and use nicad cells in labeled sets. Don't mix old and new nicads, or nicads that have been charged for different times.

• Use a safety cord to prevent loss of the wide-flash adaptor.

Appendix C: Non-Nikon TTL Strobes

	HELIX AQUA 28	SUBSTROBE MV	SUBSTROBE 100	SUBSTROBE 150	SUBSTROBE 225	OCEANIC 3000	SEA & SEA YS 100 TTL	SUBATEC S 200 TTL
Exposure control:	T/A/M	T/A/M	T/A/M	T/A/M	T/A/M	T/M	T/M	T/M
Manual settings:	full 1/4	full	full 1/2, 1/4	full 1/2, 1/4	full 1/2, 1/4	High, Low (1/2)	full	full, 1/2, 1/4, 1/8
Slave mode:	yes	no	yes	yes	yes	yes	yes	yes
Battery:	6AA	4AA	6 D	RNP	RNP	BN	4 AA	5 C
Charge time (hours):	—	—	—	3/15	3/15	12-14	12	8-9
Number of flashes:	80a, 35n	180n	200/400	150, 300, 600	120, 240, 480	up to 350	70n 130a	150, 210, 300, 400+
Recycle time (sec.):	10a, 6n	3	6/4	6/3/2	6/3/2	3.5	5n 9a	5 - 2
Beam angle:	28mm	28mm	110	110	110	110	28mm	96
Optional W/A diffuser:	yes	no	nr	nr	nr	nr	yes (20mm)	nr
ISO 100 guide number:	32/16 (uw)	24 (uw)	105 (air)	120 (air)	145 (air)	33/24 (uw)	24 (uw)	52, 36, 26, 18 (uw)
User detachable cords:	yes	yes	yes	yes	yes	yes	yes	no
Aiming light:	no	no	yes	yes	yes	no	no	10 & 20w
Approx. size (in.):	4.5 x 6	4.2 x 3.3	5 x 7	5 x 7	5 x 7	5.5 x 7.5	4.3 x 6.3	3.5 x 6
Approx. weight (lbs.):	3	1	6.25	6.25	6.25	4.5	2.25	2.75

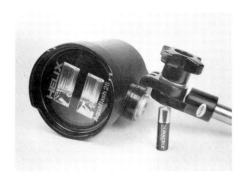

LEFT: Aquaflash 28
BELOW: Substrobes MV & 150

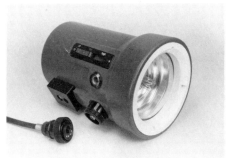

ABBREVIATIONS AND NOTES TO TABLE:

T = TTL, **A** = auto with remote sensor, **M** = manual.
RNP = removeable nicad pack, **BN** = build-in nicad battery.
3/15 = 3 hours with quick charger, 15 with slow charger.
a = alkaline.
n = nicad.
nr = not required.
uw = underwater
w = watts.

ABOVE: Oceanic 3000
LEFT: YS 100 TTL

HELIX AQUAFLASH 28

With the addition of a replacement sensor that includes a TTL mode, the Helix Aquaflash 28 can be used for TTL exposure control with the Nikonos V.

The new remote sensor has two switches: one has positions for A (automatic exposure control with remote sensor, TTL (TTL with Nikonos V), and M (manual exposure control). The other switch turns the slave sensor on or off. The strobe has switches for OFF, 1/4 POWER, MA (manual or automatic) and test flash. When the switch is left at test flash, the strobe fires a low-power signal flash every three or four seconds.

The lightning bolt (ready light) in the Nikonos V viewfinder glows when the Aquaflash 28 is recycled, and the remote sensor is set for TTL. When the sensor is set for A or M, and the strobe is recycled, the lightning bolt blinks.

Auto check indicator light. To test for automatic range when using the Aquaflash 22 and the remote sensor, aim the camera and strobe at the subject and trigger a flash with the test flash setting on the strobe. If the strobe is within the automatic range, the auto check indicator light will turn on.

TTL full-power flash signal. When using TTL, the auto check indicator light will turn on if the subject is within the automatic range of the strobe when the picture was taken—this is the opposite of the blinking ready light of a Nikon strobe. If the strobe gives a full-power flash, the auto check indicator light doesn't turn on. Note: Because the TTL system measures light reflecting off the film, you must expose film to test for a full flash.

• To estimate automatic range for TTL, without triggering the shutter, look at the back of the remote sensor unit. The f-stop shown for the film you are using should be adequate for distances up to about three or four feet.

• If batteries are low, the Aquaflash 28 may not be able to flash for several seconds after the green ready light indicates that the strobe is recycled.

• If one cell is accidentally reversed, the battery will appear to be weak.

• Remove the remote sensor if you are using the Aquaflash 28 for manual exposure control with a Nikonos III or IV-A.

IKELITE SUBSTROBES

Any of these Substrobes can be used with TTL or with the Ikelite remote sensor unit (Flash Monitor #4054 for non-TTL Substrobes, and #4055 for TTL Strobes).

Substrobe MV is a TTL version of the earlier Substrobe M that has been popular with close-up and extension tube photographers for years.
• Don't attempt to remove O-ring from battery compartment lid—the O-ring is glued in place.
• Don't overtighten the battery compartment lid.
• For close-up use, minimize arms and brackets. Ikelite handle #4077 is all you need.

Substrobe 100 is Ikelite's economy wide-beam strobe. It has fewer power settings and slightly less power than the other models, and uses individual alkaline or nicad cells.

Substrobe 150 is Ikelite's middle of the line model. The most important additional features are the removable nicad battery pack, three power settings and a higher power output.

Substobe 225 is Ikelite's top of the line wide-beam strobe. Its main feature (when compared to the Substrobe 150) is an increased power output.

• Because the built-in exposure calculator at the rear of Substrobes 100, 150 and 225 is small and hard to read underwater, make calculations in air. Attach exposures (laundry marker on white tape) to side of strobe head.
• Disconnect connector cords at the end of each day's diving, and clean and lubricate threads with a thin coating of silicone grease to prevent corrosion.
• Release pressure on quick-release snaps during long-term storage.
• Monitor quick-charger frequently. Unplug if overheating.

OCEANIC 3000 TTL STROBE

A relatively new strobe on the market at this writing, thus the authors have not had extensive experience with it. The Oceanic 3000 TTL is furnished with a sync cord for use with the Nikonos V. In the future, we would expect a TTL sync cord for Nikon SLR housed in the popular Oceanic aluminum housing.

Because both the sync cord and charger use the same port on the strobe, there is no plug to replace. Thus, flooding potential is virtually eliminated. The Oceanic 3000 TTL appears to be a relatively maintenance-free unit.

SEA & SEA YELLOW SUB 100 TTL

Introduced in the U.S. in 1985, this strobe is (at this writing) distributed in the U.S. by Graflex/Subsea.

The wide-angle diffuser fits inside the strobe. Color filter gels can also be easily installed when the strobe body is open.

The unusual features of the YS 100 TTL are the switches: one for strobe mode, one to indicate the film speed used and one to choose one of four combinations of distance and aperture. One LED display at the rear of the flash head shows suggested f stop for film speed and distance selected, and another shows the distance chosen along with the minimum and maximum TTL automatic range.

• The distance indicator lamp shows 0.3, .7, 1.3, 2 and 2.7 meters (approximately 1, 2, 4, 6 and 10 feet, respectively). If you have trouble converting meters to feet, attach a conversion table to the top of the strobe.
• The apertures shown on the aperture LED display appear to be for bright, reflective subjects in clear water. If conditions are less than ideal, open by an additional stop.
• Don't depend on the slave sensor. Located on the top of the strobe, it is often overpowered by the bright surface above.

SUBATEC S 200 TTL

Made by Subatec, in Switzerland, and distributed in the U.S. by Akimbo, Inc., this new TTL strobe has an interesting feature: It can be set for both TTL and full, 1/2, 1/4 or 1/8 power. Thus, you can use a low power setting to reduce the strobe output for fill lighting (see pages 56 to 59) or to balance strobe with sunlight. If, for example, you set the lens for an f8 sunlight exposure, and set the S 200 for TTL and a power setting that produced an f5.6 exposure, you will have strobe light that is one stop weaker than sunlight.

SUBATEC S 250 TTL

Not released at this writing, the S 250 TTL should have twice the battery capacity of the S 200 TTL. Thus, although power output and recycle time should be the same, the number of flashes at any given power setting should be double that of the S 200 TTL. Other features should be the same for both the S 200 TTL and S 250 TTL.

Appendix D: Non-Nikon W/A Lenses

SEA & SEA WIDE LENS 17

The Sea & Sea 17mm wide-angle lens is distributed by Graflex/Subsea in the U.S., at this writing.

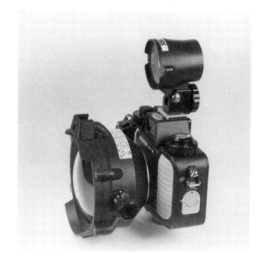

Focal length: 17mm
Apertures: f3.5 to f22, click stops.
U/W picture angle: 86 degrees, diag.
Dome port to eliminate distortion.
Body: reinforced ABS plastic.
Focus: 0.35m (13.8 in.) to infinity.
Weight: slightly less than one lb.
Dimensions: approx. 3.5 by 4 inches.

The Sea & Sea 17mm Wide Lens, which replaces the older Sea & Sea 18mm Wide Lens, offers two new features:

1. The 17mm lens can be used with the built-in metering systems of both the Nikonos IV-A and V cameras. The older 18mm lens couldn't be used with the automatic controls—it limited you to manual controls only.

2. The 17mm lens has an aperture range of f3.5 to f22. The older 18mm lens had an aperture range of f3.5 to f16.

Both lenses have the aperture control knob on the right and the distance control on the left, with the distances shown in meters. Neither lens has a depth of field scale, but the 17mm lens we examined had a depth of field decal on the top.

The Sea & Sea Optical Viewfinder is adjustable for parallax, and has masks that can be installed for use with narrow-angle lenses.

SUBAWIDER II

Manufactured in Switzerland by Subatec, and distributed in the U.S.A. by Akimbo, Inc., the Subawider II is a wide-angle lens accessory that is a press fit over the front of a Nikonos 35mm lens. It widens the picture angle

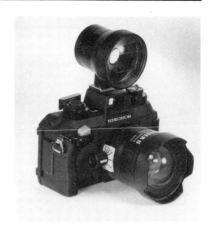

The viewfinder, which is included with the Subawider II, has an etched rectangle for use with only the 35mm lens, as well as a larger viewing area for use with the Subawider II.

to about 90 degrees, which approximates a 20mm lens. It will cause vignetting if used on the 28mm lens.

SUBAWIDER II PRACTICAL TIPS

Eventually, the aperture and focus decals may fall off, but this presents no problem:

•To set the aperture of focus, look directly through the front of the dome port—you can read scales inside.

•When setting the focus (distance), you can simply use the metric scale. When the Subawider II is added, the focus is changed by about 1/3rd. By coincidence, you can thus use the meter scale as if they were feet. In other words, three "meters" on the 35mm lens scale now means three "feet" is the focused distance with the Subawider II. When looking through the front of the dome, you don't have to make a mental conversion—the meter scale is the only one you can see.

If the surfaces of the Subawider or viewfinder become scratched, use toothpaste and a damp cloth to smooth over any rough edges. Use a circular rubbing motion.

The top and bottom of the viewfinder is masked by a frosted finish on the plastic. Cover these areas with black tape so they don't distract your attention when you are viewfinding.

The Subawider II is optically sharper at apertures of about f8 or higher. Wider apertures will reduce sharpness.

Be sure to secure the lens and viewfinder with a cord. The viewfinder can easily float away.

Remove the Subawider underwater and remove any bubbles from the lenses.

Be sure that it is seated squarely and the notches on the lens hood correspond to the corners of the picture area. If you get black shapes along opposite corners of your slides, or along one side, it is turned or not seated properly.

Decals for apertures and distances are attached to the sides of the 35mm lens mount, and marks on the control knobs are used to set the controls.

Although a depth of field scale isn't provided, you can use tape to attach depth of field data for a few basic aperture and distance settings to the Subawider II body. At a focused distance of one meter, for example, and an aperture of f5.6, depth of field extends from about 2 to 12 feet.

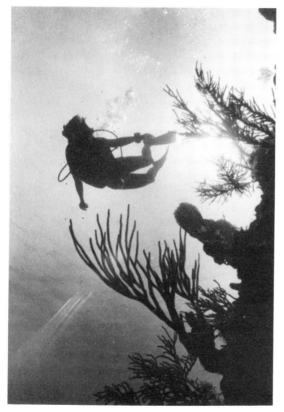

Taken with Nikonos 35mm lens and Subawider II, Grand Cayman, B.W.I.